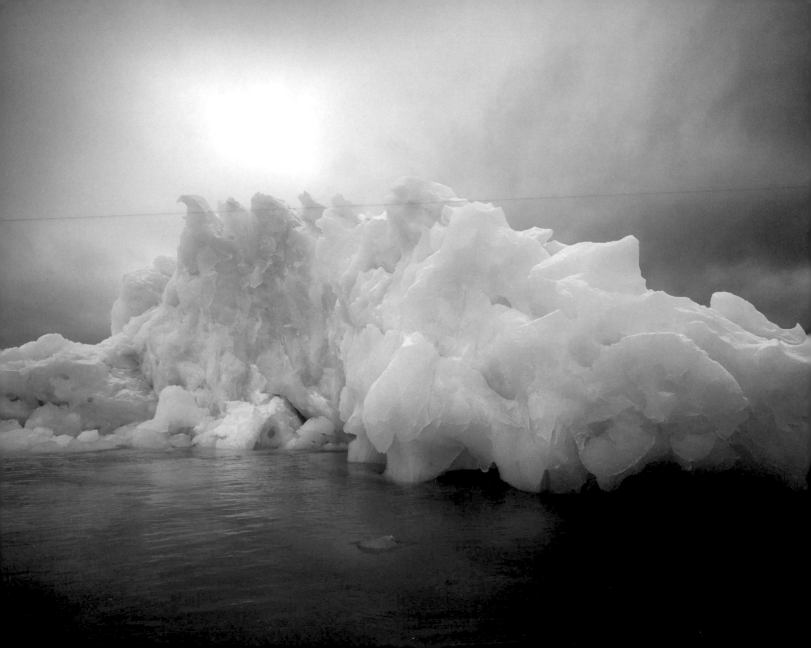

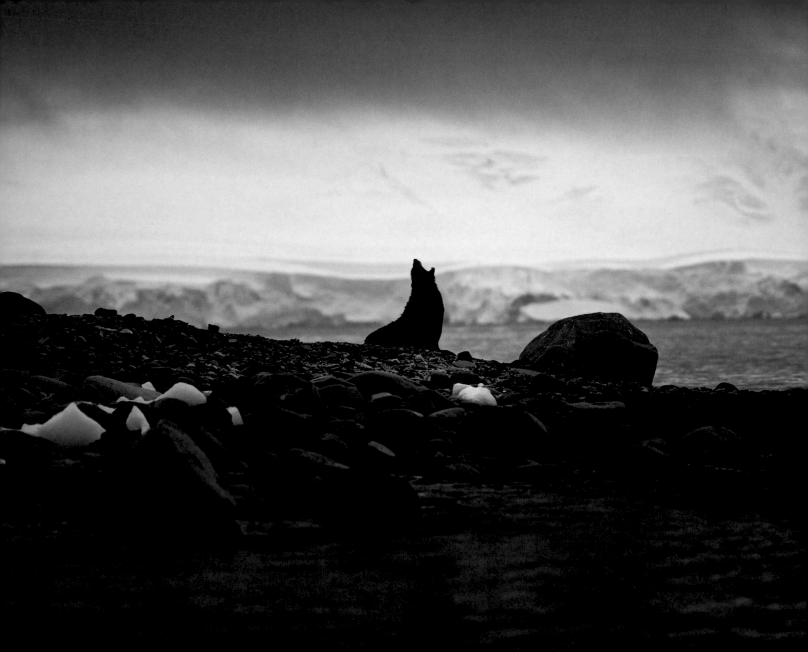

ANTARCTICA

A CALL TO ACTION

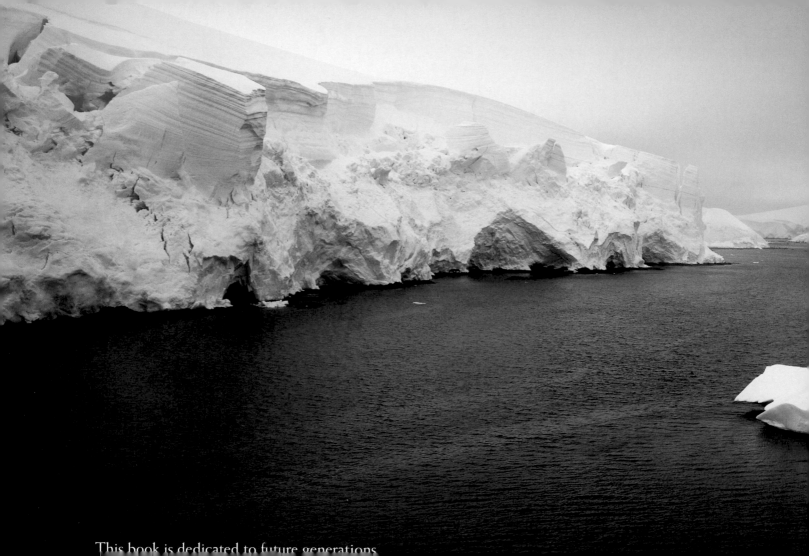

This book is dedicated to future generations

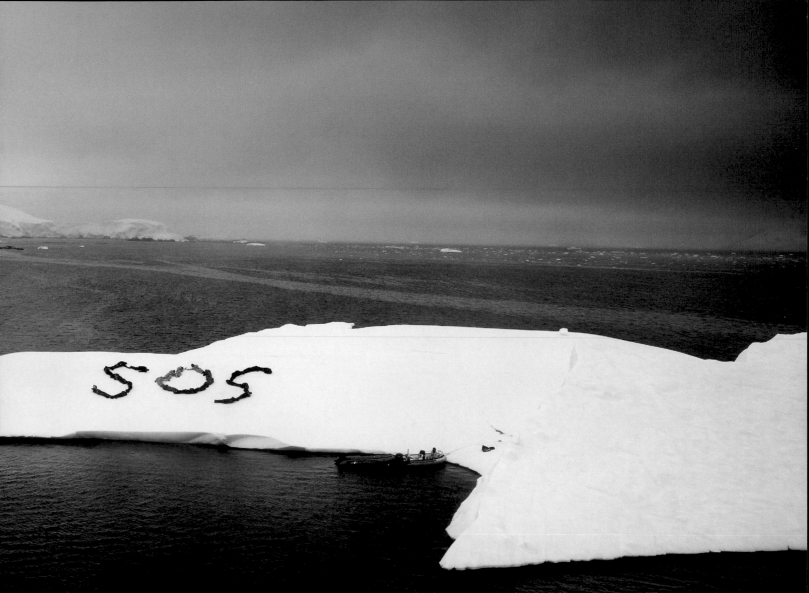

"We are called to a task greater than that demanded of any generation in human history: to preserve our planet and our species. In accepting this challenge we are also called to recognize, develop, and redirect the awesome power of our minds, and to consciously choose and create our evolution."

—Roger Walsh

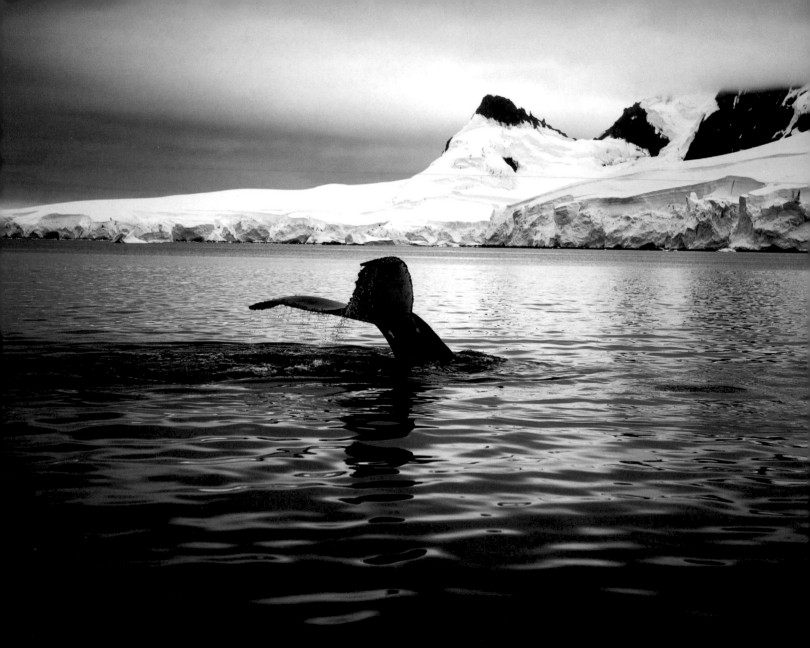

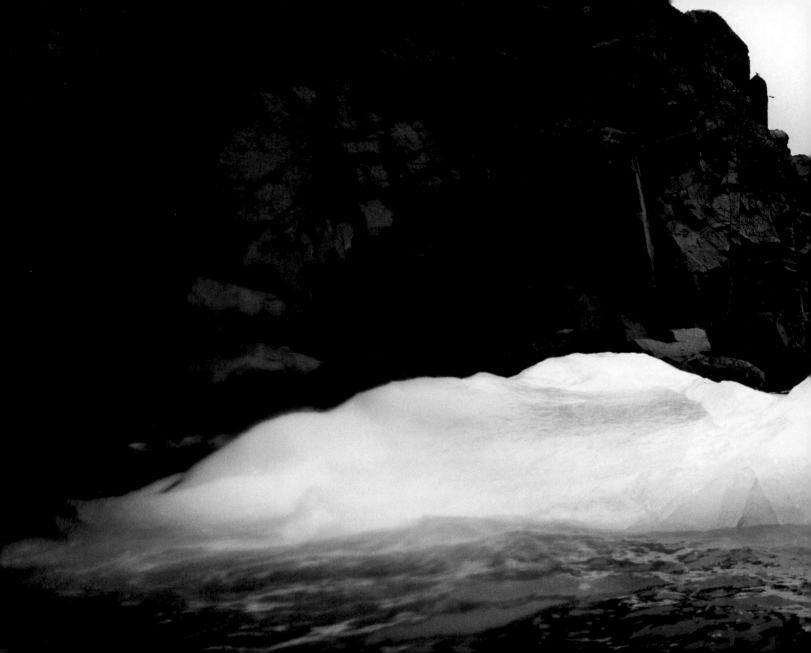

ANTARCTICA

A CALL TO ACTION

SEBASTIAN COPELAND

foreword by ORLANDO BLOOM

EARTH AWARE
San Rafael, California

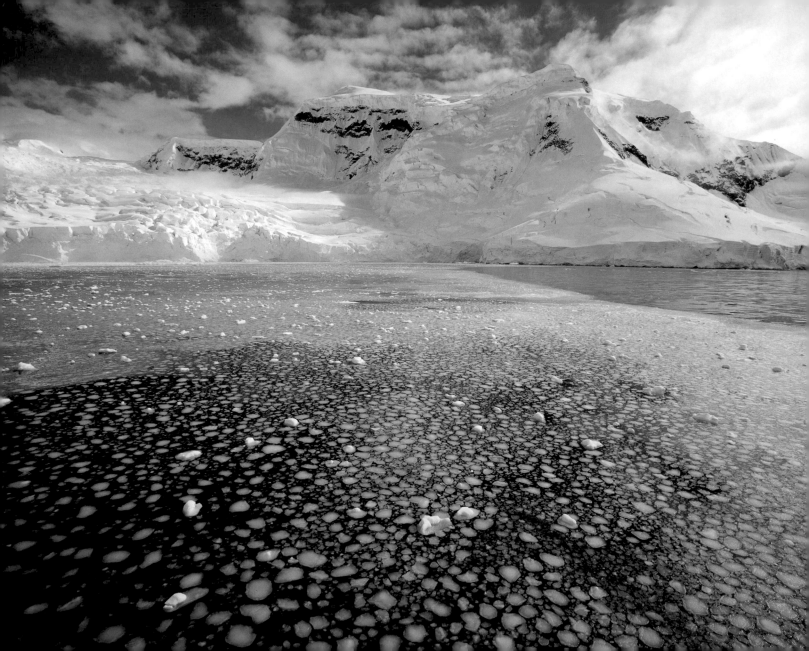

CONTENTS

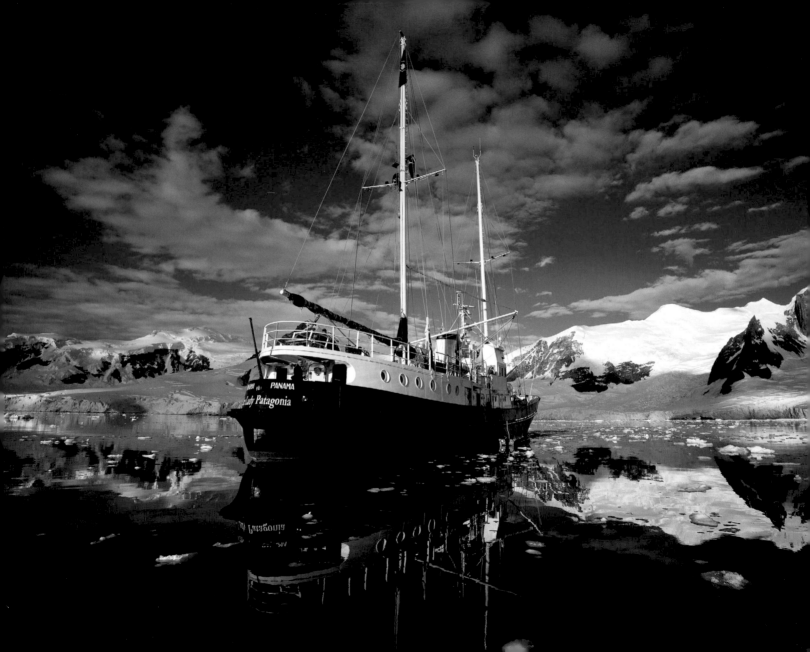

FOREWORD BY Orlando Bloom

My cousin asked me to take a trip with him to Antarctica in December 2006. It immediately appealed to me—the promise of the adventure, the wide-open seas. This would be the journey of a lifetime and would fulfill my longstanding dream of witnessing a seldom-visited environment that is increasingly threatened by the way we live today. Although in reality it seemed a daunting idea, the opportunity was too good to miss.

My cousin's enthusiasm is always contagious. He's a true adventurer and a passionate believer that it is within our grasp to make a difference. For as long as I can remember, the environment has always been a great topic of conversation between us. With his knowledge and insight, I always felt as if I had a privileged view into what was really happening to the world around me, and so the opportunity to see it up close for myself was a gift.

I had seen the images from his first trip to the south in 2006 and was intrigued to find out more, to experience the Ice firsthand. This was also a chance for us to embark on yet another adventure together.

No words, no conversation, nor photographs could have prepared me for this experience. We left Ushuaia, the world's southern-most seaport, on January 20th, 2007, for a three-day crossing to Antarctica. The Ice Lady Patagonia, a decommissioned 1950's Norwegian coastguard icebreaker, would be our home for the next month. With its Spartan accommodations, this was hardly a luxury cruise.

Moving through the Drake Passage is literally a rite of passage for anyone entering this precious land. It is also, as my cousin jokes, "What separates the men from the boys."

Three days on the open seas, crossing the most treacherous body of water on Earth, is enough to clear one's head of all the trappings of everyday life. We would have no communication whatsoever with the outside world until our return to port. And for me, that would be a gift.

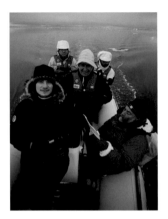

It is impossible to put into words the feeling of my first sighting of an iceberg on the horizon. Like modern-day dinosaurs, these towering blocks of ice are nine times greater below the surface and lay in tranquility, reminding me of a land hardly known and of a time long forgotten. But what struck me most was the deafening silence that would be interrupted only by the occasional screech of a gull, a penguin, or a breaching whale. This was a true natural wonderland, untouched by man. One can't help but feel humbled—and yet connected—when one truly understands our position in the natural order, that we are only one of 30 million species inhabiting this planet.

Life on the research icebreaker fell into a rhythm of shared tasks and responsibilities. But making landfall off the zodiac, scuba diving, or climbing an iceberg (only to snowboard down it) more than fulfilled any childhood dreams of adventure and voyaging the great outdoors.

Because I had never experienced an environment such as this, I had nothing to compare it to and it would not be honest of me to claim that I witnessed firsthand the changes taking place due to global warming. But what I did witness was a vibrant and powerful ecosystem which felt both majestic and incredibly fragile. To know that minute shifts in temperature, which have been stable for thousands of years, have such a huge impact on the balance of this place is an upsetting reality. The idea that the way we live our lives day to day has such an enormous impact on the natural cycle of the earth is a very hard concept to grasp. And yet the accelerated melting of the ice has consequences on our lives thousands of miles away, from our seasonal crop cycle to our basic water usage. These are truths upon which scientists around the world have unanimously agreed. A hurricane in London at the end of 2007, the water shortage in Atlanta, and the heat waves in New York in the fall of 2007 were all but a few signs pointing to a shift in the natural cycle that impacts our daily lives.

It is my hope that the images my cousin has captured so dramatically and with such commitment will incite people to learn more and to appreciate what is truly at stake.

We are all invited to escape within the pages of this beautiful book but, more importantly, this is a call to action for each of us, to learn to appreciate what we can do to protect and cherish our own backyard, this remarkable environment, Earth: our home.

Thanks and respect to my cousin.

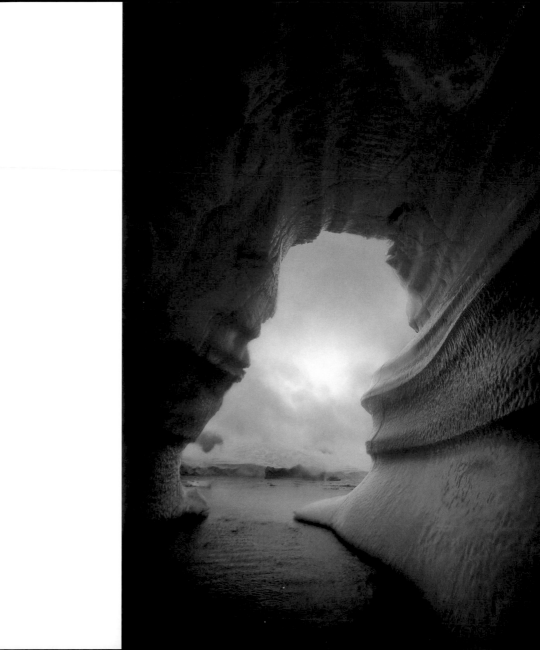

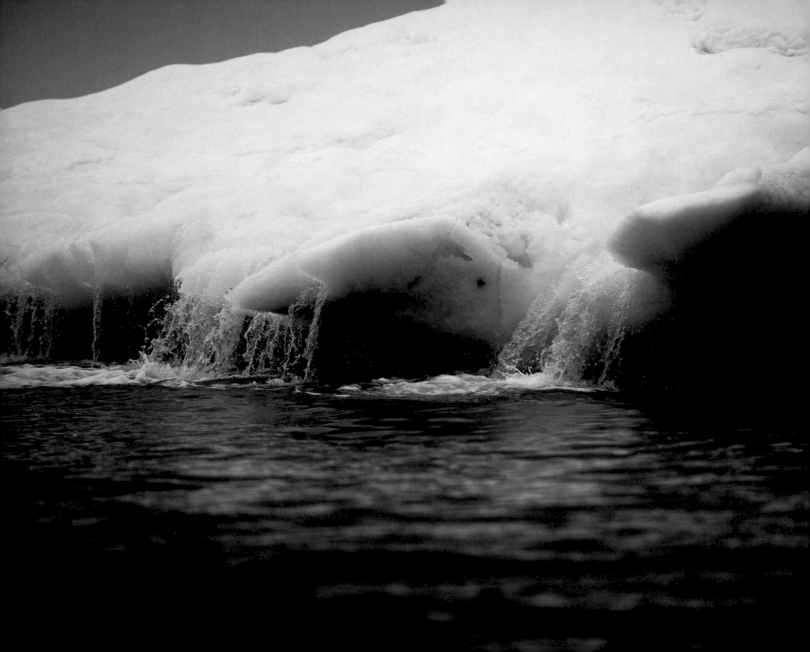

INTRODUCTION BY Sebastian Copeland

Antarctica lives in my memory as a sanctum of pristine natural beauty. A world tucked away, happily frozen in time, the Antarctic continent has thrived in its natural state for millions of years, conveniently out of reach of human interaction. It wasn't until 1821 that men set foot on this virgin land. Given its extreme climate, it has remained largely untouched even to this day—on the surface at least—by the human footprint.

At one and a half times the size of Australia, Antarctica doubles in size in the winter.

Like the great lungs of the Earth, the sea ice at the poles expands and shrinks with each seasonal cycle, taking in enough ice to carry the planet over through the next season, and cooling it in the process. They are the air conditioners of the globe, and help regulate our ecosystems—from temperatures and seasons, to the relationship the Earth has to water. In this way, the poles have played a key role in sustaining our global average temperature of 59°F, which has defined human development and agricultural prosperity for the last 15,000 years.

But then came industrial development, fossil fuels, and demographic growth. Advances in technology and an unbridled human pursuit of affluence have unleashed our voracious appetite for consumption. Tending to an ever increasing and demanding human demographic, what could be seen, at first, as candid and creative zeal has evolved into a blatant and alarming disregard for the hand that feeds us. Unrestricted growth soon mutated into a virus infecting the planet. The last century and a half has seen growing anthropogenic changes affecting every aspect of biological life.

The poles are barometers to the world: they are the fragile icons of the relationship of cause and effect. Today, the Earth is 1.4°F warmer than it was 100 years ago and computer models

point to an increase of 4°F by 2100. These changes may seem minute, but in environmental terms, they have profound consequences and have the power to destabilize entire ecosystems. By the end of the summer in 2007, scientists were confounded as they witnessed the largest depletion of Arctic summer ice ever recorded—over a half a million square miles, equaling the size of Texas and California combined. Some now predict that the ice could be all but gone in the summer by as early as 2013. Meanwhile, the Antarctic Peninsula has been warming at five times the global average, or 1°F every decade for the past fifty years. Sea ice over the western Antarctic Peninsula has receded by 40 percent in the last 26 years.

As the melting reflective cover of ice darkens into sea, it absorbs, rather than reflects, 80 percent of the sun's heat, precipitating this vicious cycle. Locally, the loss of sea ice is reducing the krill population in Antarctica—the small shrimp-like crustaceans that dominate the penguin, seal, and whale diets. Consequently, there has been a steady decline in many penguin rookeries—themselves a staple diet for seals. Additionally, this warming trend is introducing a new form of vegetation, since grass was discovered to grow and survive the Antarctica winters. All things in nature have a causative relationship; all of them with consequences. The introduction of new organisms in Antarctica has some scientists worried that the balance of its fragile ecosystem would likely be impacted.

To complicate matters, Antarctica's complex climatic environment can provide distracting fodder for the environmental skeptics. It is true that some areas are seeing colder temperatures in the central plains and higher elevations; and more precipitation in coastal areas. But those precipitations are due to an increased melt season. Regardless, unprecedented warming trends in the Peninsula are destabilizing glaciers, which are now pouring into the ocean at a faster rate than ever before. As I write this, word comes in that the Wilkins ice shelf has just lost an area the size of Connecticut. The Wilkins, like the Larsen B before it, will not raise ocean levels. But like many ice shelves, they are a protection barrier for the interior glaciers, increasing their risk of slipping into the ocean. And melting glaciers DO raise ocean levels. The Antarctic Peninsula's glaciers have the potential to increase ocean levels by as much as twenty feet. This presents a dramatic threat to 80 percent of the world's population living in low-rise coastal areas, given that one hundred feet of coastal land is lost to each foot of rise.

There are good reasons to believe that these changes are tied to human activities. Indeed, the concentration of CO_2 into the atmosphere—which had never reached beyond 300 parts per million (PPM) in the last million years—has increased by almost 100PPM in the last century and a half alone. Today, humans pour seventy million tons of green house gases into the air every twenty-four hours. 2007 saw a new record jump in CO_2 levels, increasing by 2.4 PPM. At the present rate, carbon dioxide output will grow 75 percent by the year 2030. If this were not enough, the methane once trapped in the great North's permafrost has seen a sudden jump as it is being released due to these thawing temperatures, further increasing the levels of green house gases into the atmosphere; that thin layer which has uniquely enabled our planet to create and support life.

As the Earth is inhaling greater amounts of carbon dioxide, the poles are exhaling less ice over the course of their seasonal cycle; ice shelves are disintegrating; glaciers are disappearing

and the mean temperatures of both the air and the seas are rising. With each contaminated breath, the complex biological balance of the Earth, as we know it, dies a little.

On the anthropogenic scoreboard, climate change does not list as our only accomplishment. Genetically modified food; polluted rivers; poisoned air; contaminated soils filled with plastics, heavy metals and chemicals; depleted water beds—these list as some of the facts that we have come to accept as the currency of doing business. And while both trees and the oceans are natural off-sets to green house gases, human activities impede both from cleaning the atmosphere. 80 percent of the world's original forests are now gone; the Amazon is losing 2,000 trees—the equivalent of seven football fields—every minute; and in the US, only 4 percent of original forests are left. Meanwhile, the oceans' warmer temperatures are reducing their capacity to absorb CO_2. The increased acidity in our ocean's pH balance—tied to rising temperatures—is suffocating plankton life and destroying corral reefs around the globe, both of which serve as the foundation for the food chain. Additionally, the oceans are still a dumping ground for sewage as well as industrial wastewater, including mercury and many heavy metals. Despite these damning assessments, 70 percent of global fisheries are operating at, or exceeding, capacity. All the while a sudden lack of nutrient-rich ocean upwelling, caused by rising temperatures, is slowing the reproductive cycle of many varieties of fish. Still, industrial fishing fleets throw an estimated 16 billion pounds of unwanted or premature catch back into the ocean, dead or half dead. It is easy to see how this cycle self-perpetuates. Today, only 10 percent of large predator fish are left in the ocean, while other marine species are increasingly posted onto the endangered list. The disappearance of ice has a major impact on ocean conditions, currents and temperatures and the migration of fish populations. Today, most scientists believe that the oceans are on the verge of a virtual collapse.

In seeking progress, humanity is choking the natural world out of its ability to provide for us. The World Wildlife Fund now predicts that by 2050, resources will be consumed at twice the rate that the Earth can renew. Our reliance on old technology to produce power and our attitude towards waste must be re-thought. These changes do not merely beg a re-examination of population growth and consumption, they demand an urgent and global commitment to the principles of sustainable development.

Over a hundred years ago, the Swedish chemist, Svante Arrhenius, predicted that pouring CO_2 into the atmosphere would likely increase the Earth's average temperature. Today, while the ice is disappearing, we are bidding out the Arctic to plunder it for oil in spite of the Mineral Management Service's conservative assessment that each platform has a 33 to 55 percent chance of a major spill and that the broken ice would make recovery and cleaning efforts virtually hopeless. Oil in the Arctic, given the exponential growth of global demand, is a short-term solution according to even the most aggressive projections. This alone would make the case for a global support of alternative and sustainable energy programs and a provision for large government incentives aimed at research and development for new technologies. But we contend with powerful lobbies intent on maintaining—and capitalizing on—their share of this vanishing legacy. Today, the US government still provides largely biased tax incentives to oil interests, in

spite of the industry's multi-consecutive years of record-breaking profits. It is imperative that the vision and creativity which has defined the American spirit of entrepreneurship lead us out of this destructive cycle. We cannot wait until 2012 to ratify Kyoto, for the simple reason that changes have accelerated far more rapidly than Kyoto initially predicted. We must demand an international treaty within the next two years, enforcing a 90 percent reduction of GHGs by industrial countries within the next thirty years, and more than half by the rest of the world. By eliminating hand-outs to dirty coal industries and supporting "green collar" businesses we can speed up a market transformation towards a sustainable economy, create jobs and stimulate economic growth—while fighting global warming.

From an environmental standpoint, we are out of the "tree-hugging" business. The last few years, replete with natural disasters and economic challenges, have forever changed the landscape of our collective consciousness and forced us into the beginning stages of a global environmental awareness. It has also stimulated our intellectual resourcefulness by presenting solutions to reverse this problem. But we have a long way to go and the issue is time. We can no longer solely rely on our business and political leaders; it is time we take stock of the individual accountability we all share to cherish the condition of our existence and protect the source of our survival. This is an "all hands on deck" moment in our history. Because our goal, ambitious though it is, must be to return to a more sustainable existence, inspired by the species depicted in this book. That is what I hope to address with this Call to Action.

With this book, I wish to invite people on this voyage—to take them into their garden and connect them with their natural playground; its magnificence, its perfect beauty and its balance. Otherworldly, exotic, and distant though it may seem, this is our world and it is shrinking. Activities that we have taken for granted are impacting this fragile ecosystem, thousands of miles away. And the consequences are having powerful ramifications on the rest of the planet and its geopolitical balance. We all share the responsibility to preserve this remote part of the world in order to preserve ourselves. Because our activities are not just dooming to the environment—they are dooming to us. It is my hope that this book's visual record may invite viewers to stop and reflect while its Call to Action may inform and inspire the beginning of the difficult but necessary steps towards positive change. To fulfill the promise of our potential and to define the nature of our legacy.

I dream of a world where cars are silent and produce no air pollution, where waste is bio-degradable and energy is resourced naturally and sustainably using air, water and the greatest energy source in existence—the sun—and where the benchmark of social development is to leave no trace in our soils, our oceans, and in the air we breathe. I dream of a world where the future of our children is our most valuable commodity. We have, as Al Gore eloquently put it, a generational mission. A uniting opportunity to put our collective intellectual resources to work towards a universal goal, one that carries the utmost moral consequence: our future.

That time is upon us. Welcome to the "Age of the Environment."

—Los Angeles, May 28, 2008

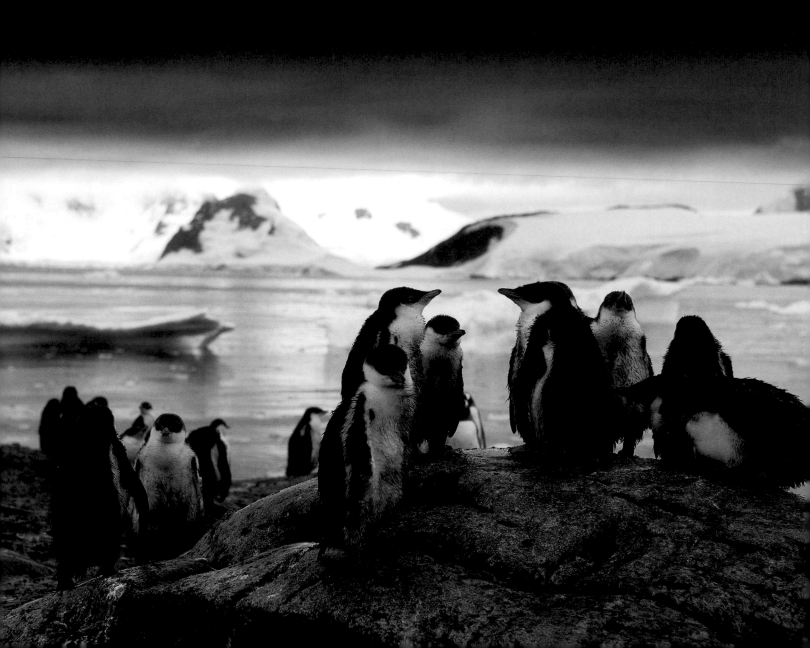

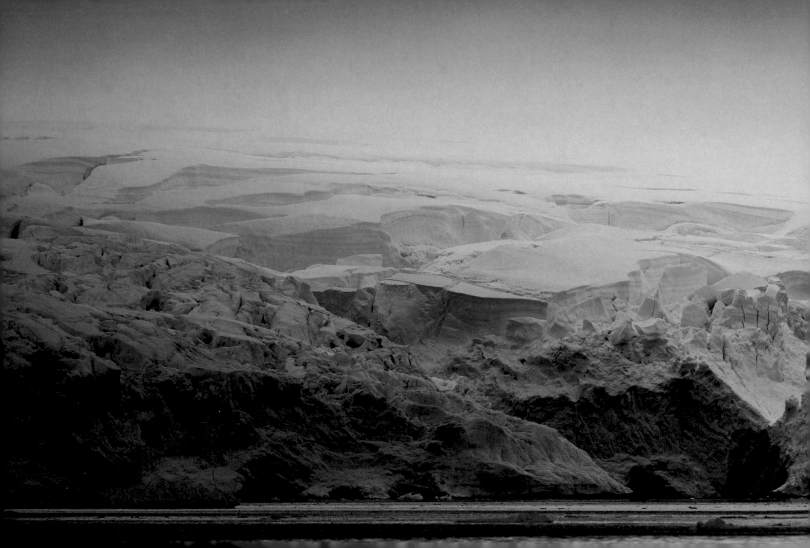

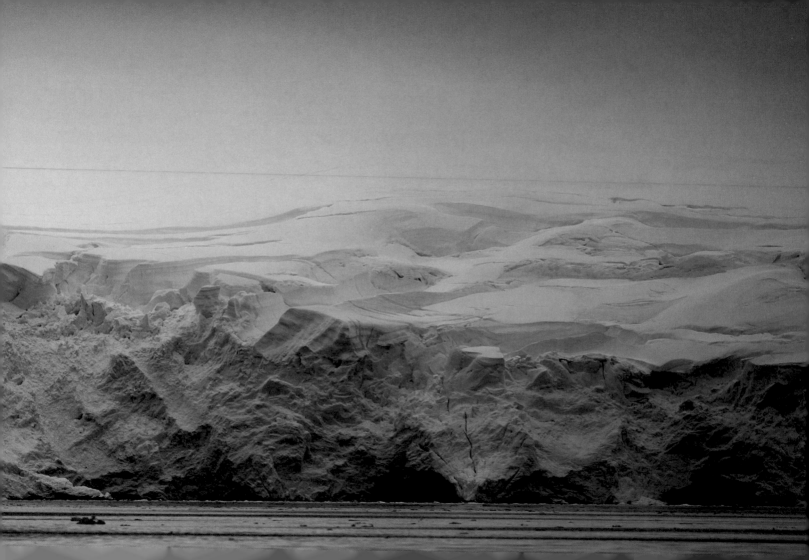

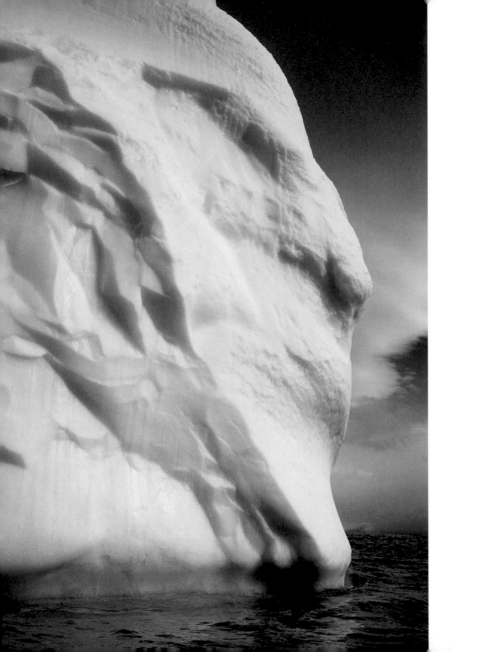

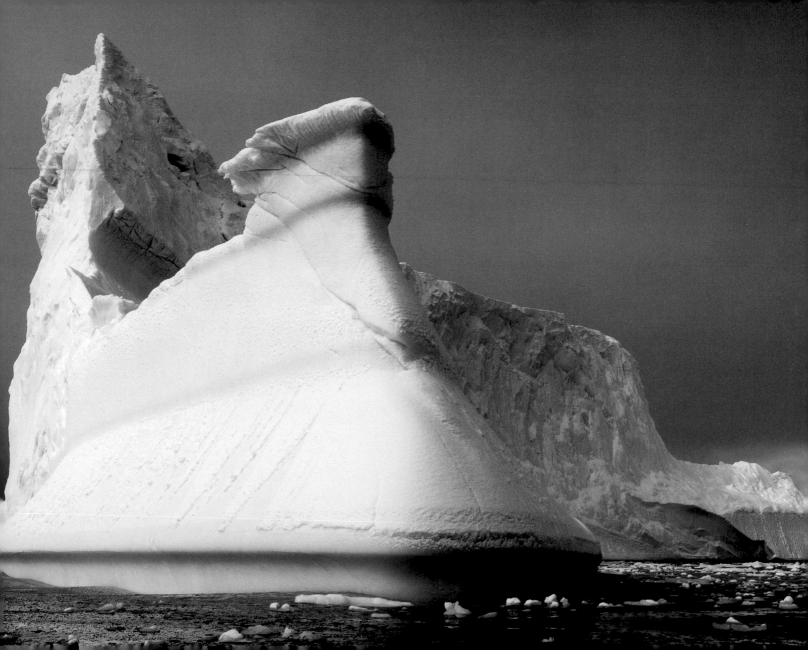

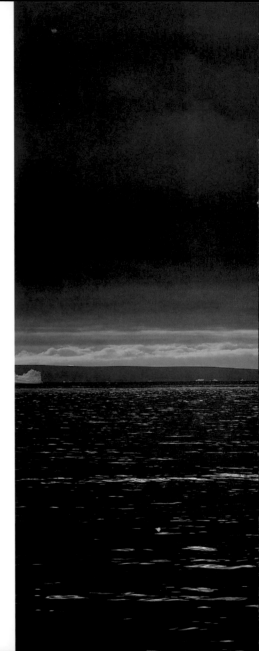

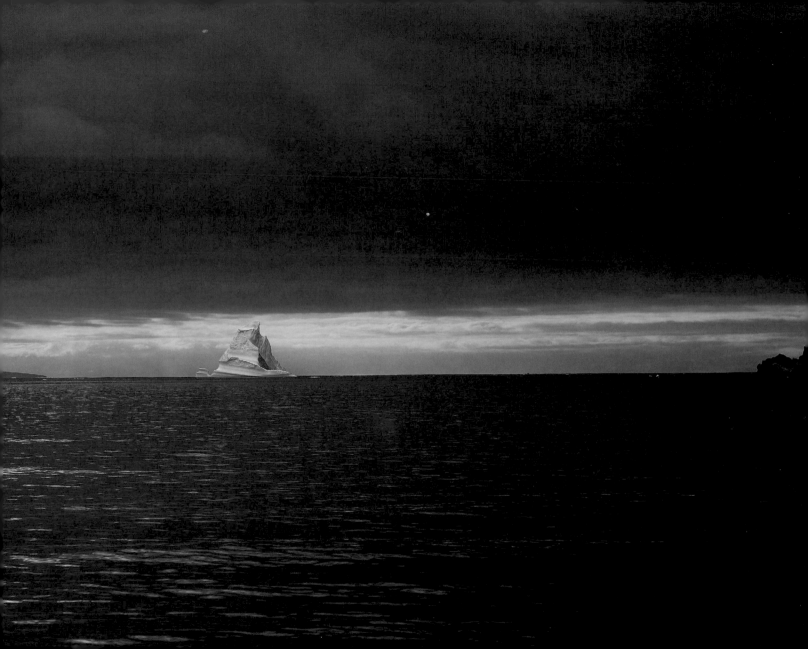

Will Steger

In 1990 I led an international team of six people on the longest-ever traverse of Antarctica. Traveling on skies, along with three dog teams, we spent 221 days on the 3731-mile journey.

My greatest memory was the crossing of the Larsen Ice Shelf on the Antarctic Peninsula. Here we were introduced to the paradox of Antarctica, to its pristine beauty and to its brutal storms that humbled us with their awesome power. We traveled for a month across the shelf's vast surface. At times we were lulled by the silence and calm of the peninsula's panoramic, glaciated mountains; then a sudden storm would engulf us, threatening our lives.

This platform from which we first experienced Antarctica is now gone forever. Victims of global warming, two of the three sections of the Larsen Ice Shelf—an area larger than the state of Rhode Island—have recently collapsed into the ocean. The loss of more than half the Larsen in little more than a decade heralds the seriousness of humankind's complacency in the face of the environmental challenges that lie before us. What is now happening in our planet's remote polar regions will soon affect us all.

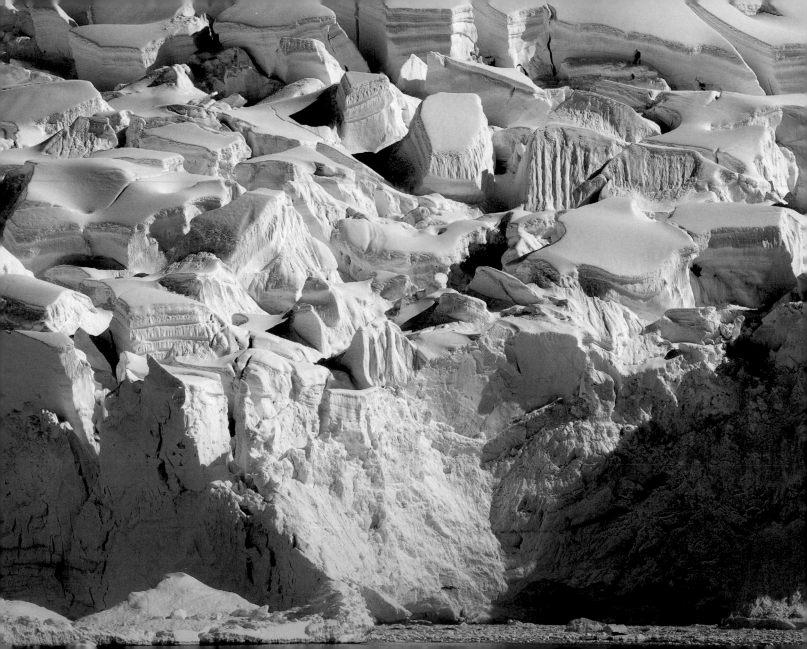

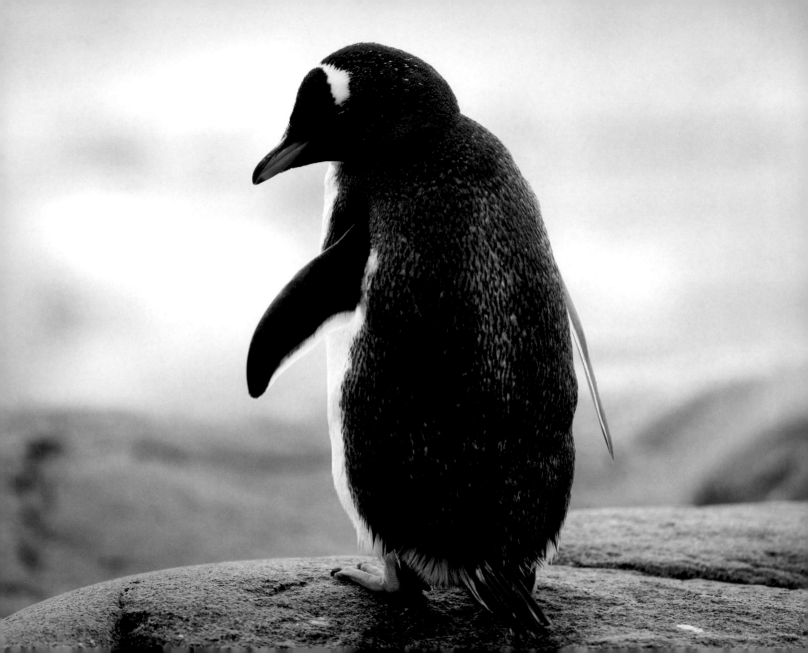

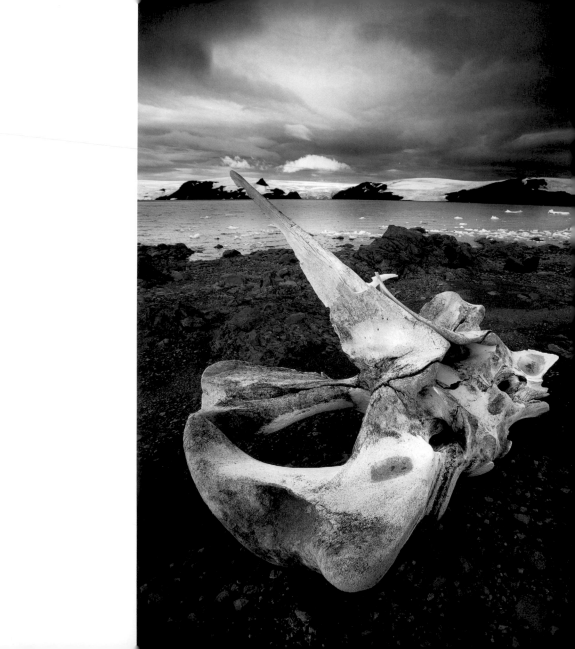

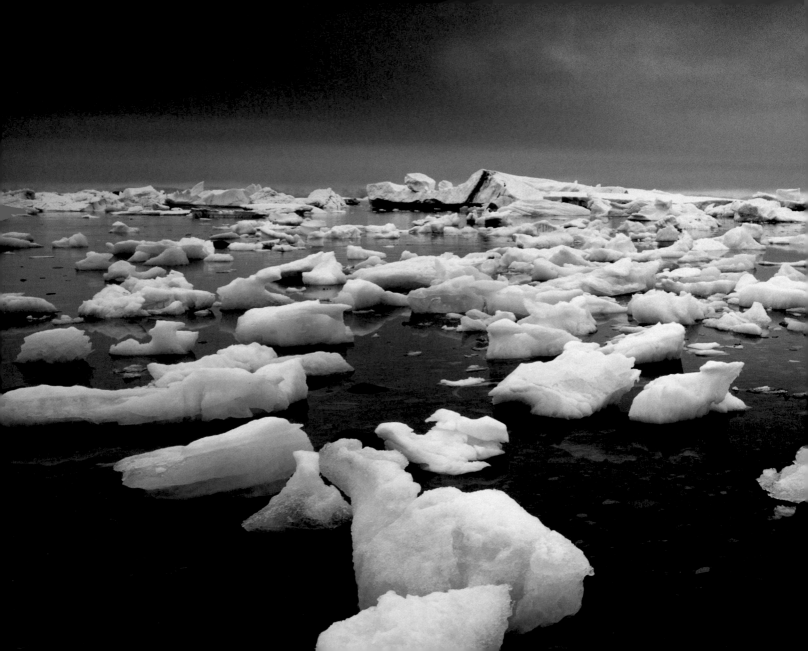

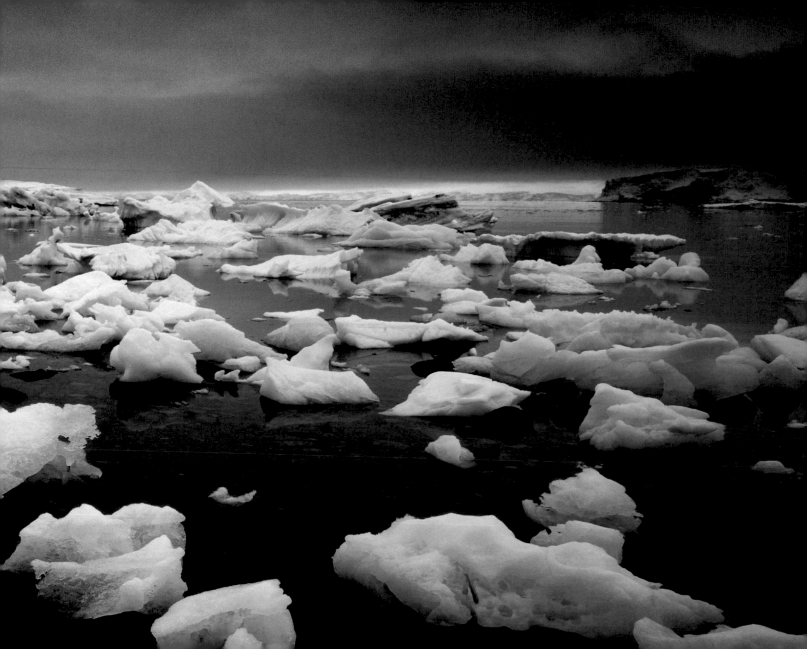

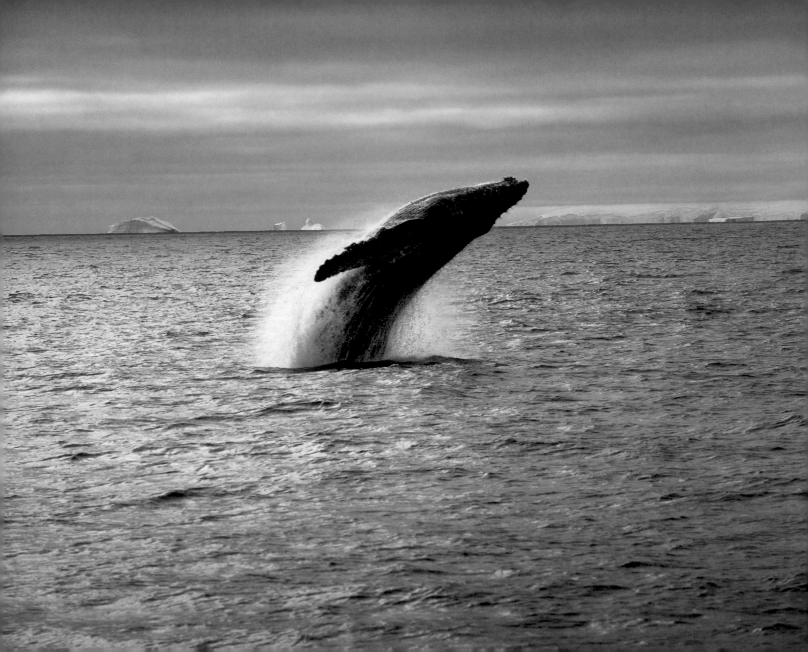

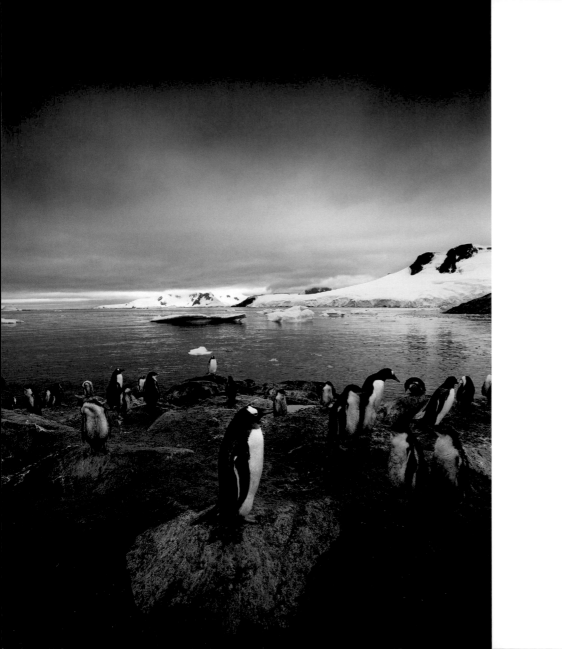

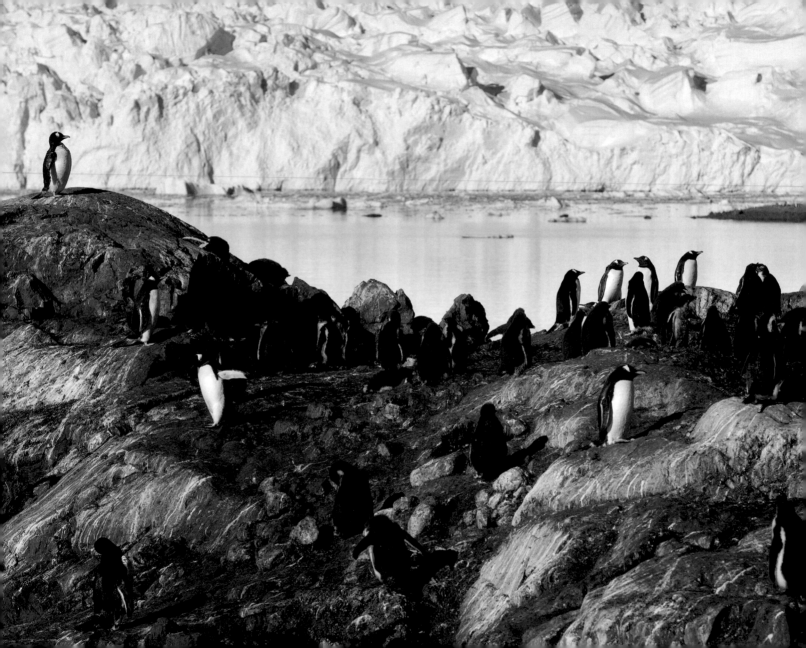

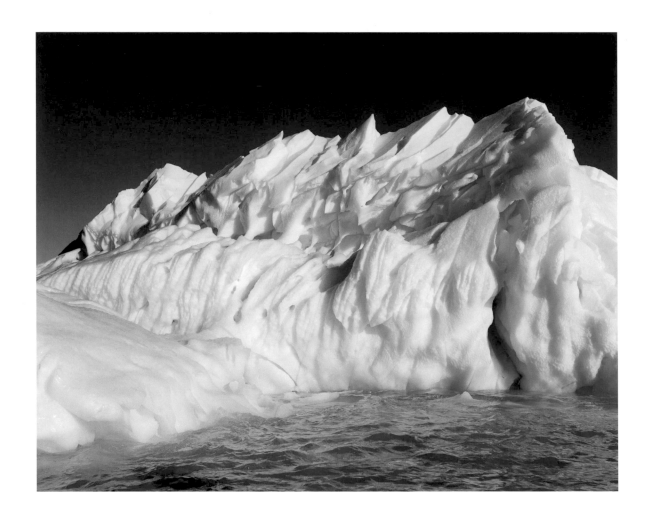

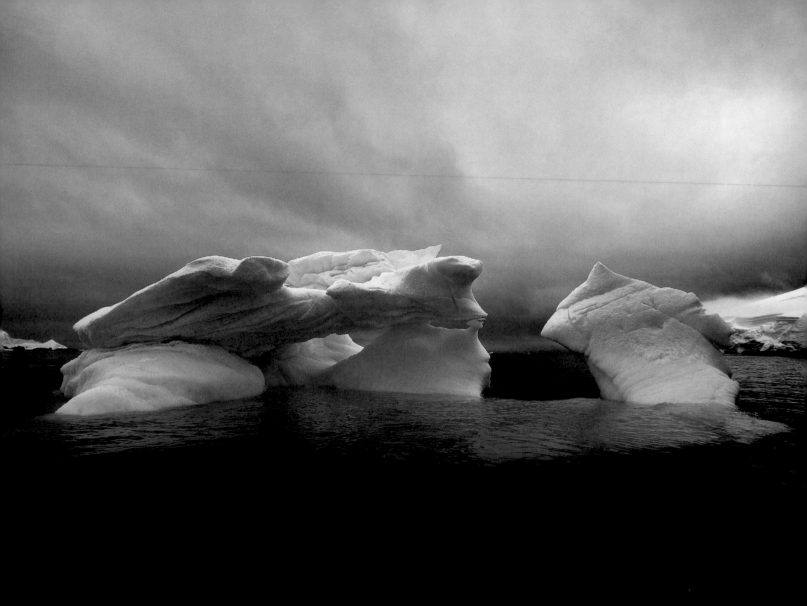

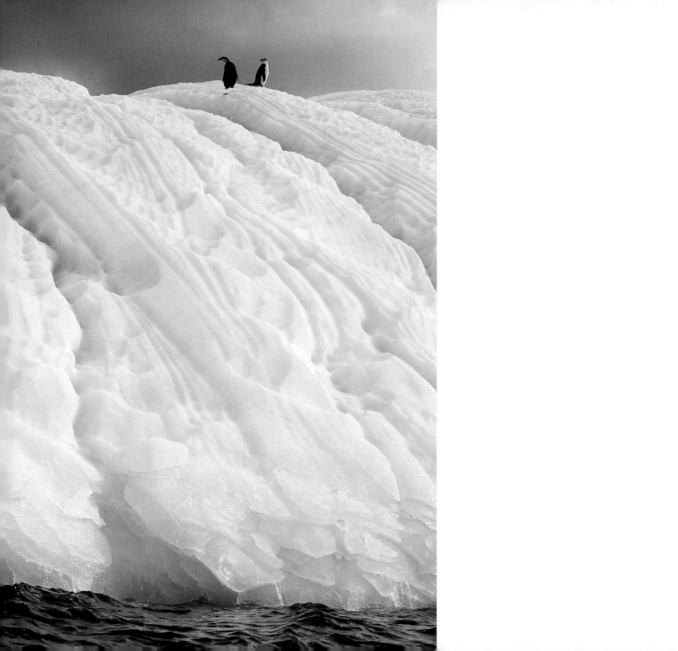

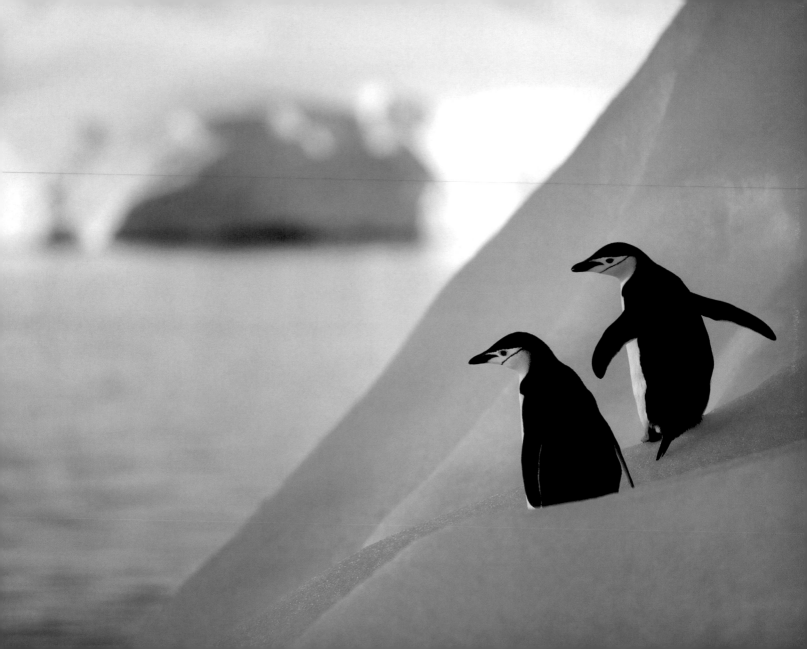

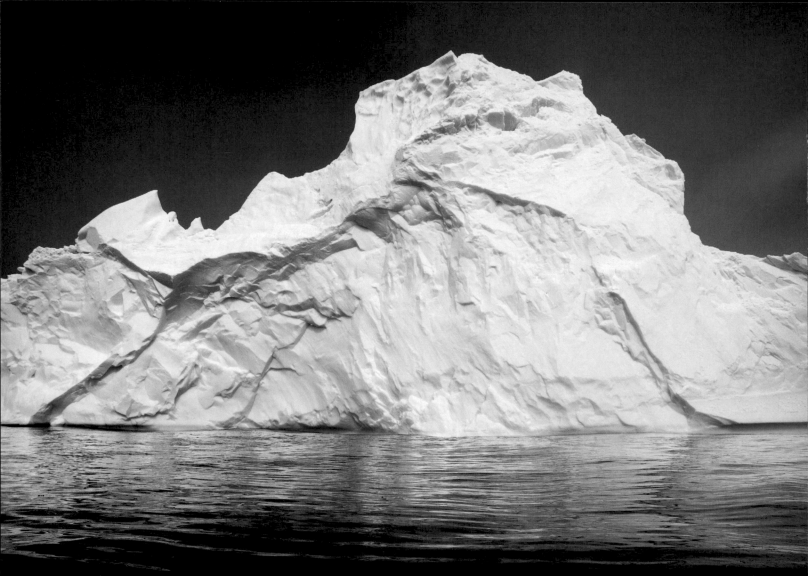

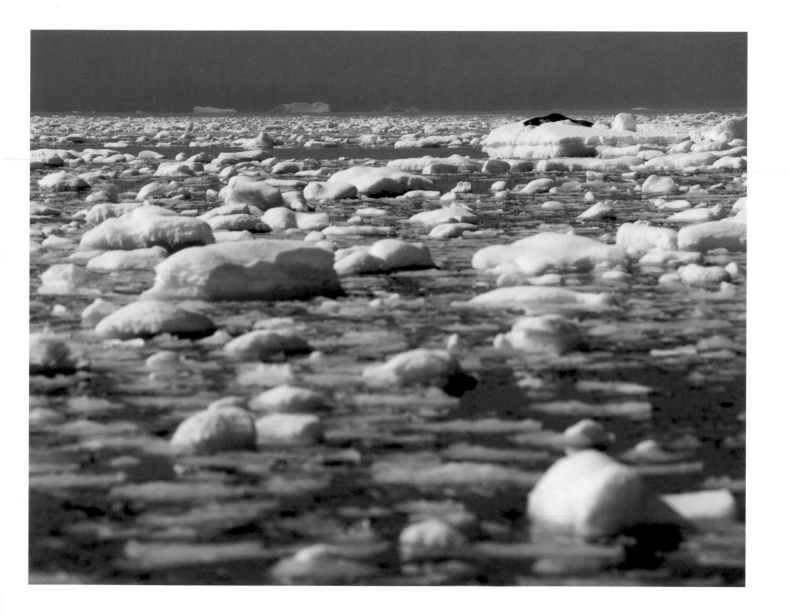

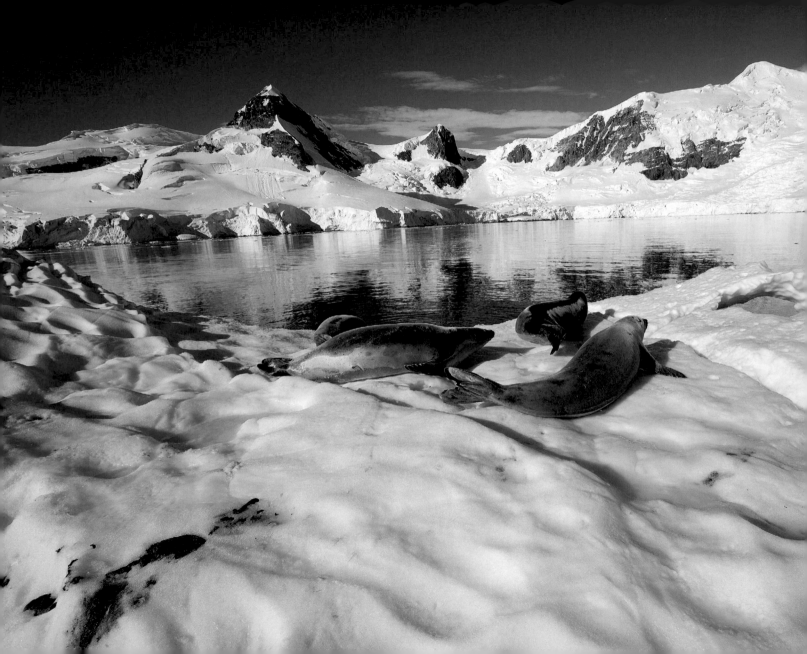

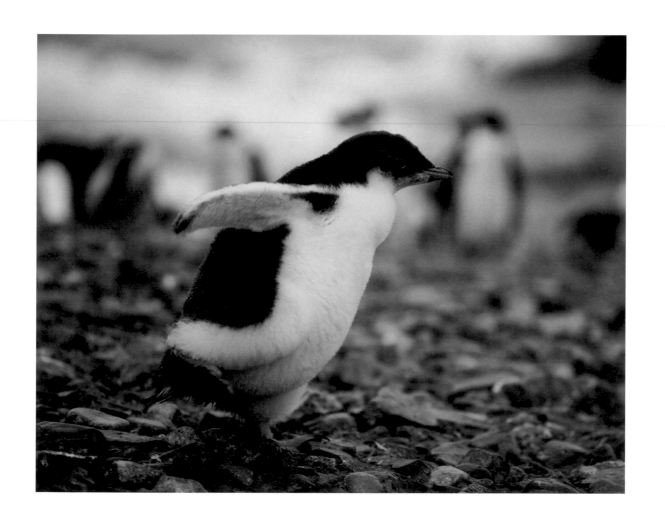

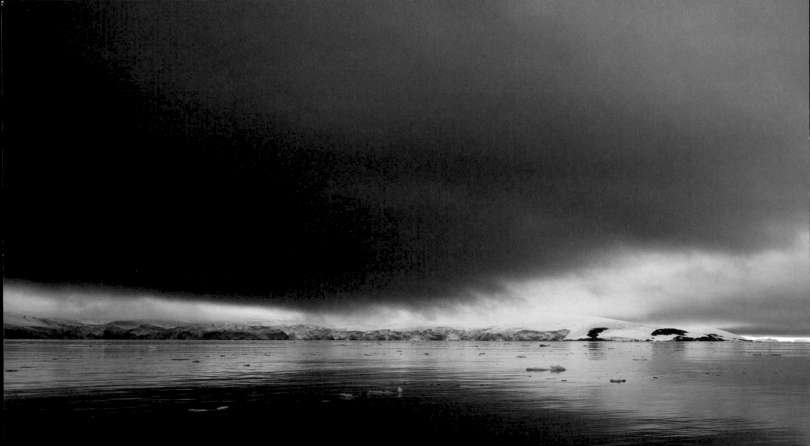

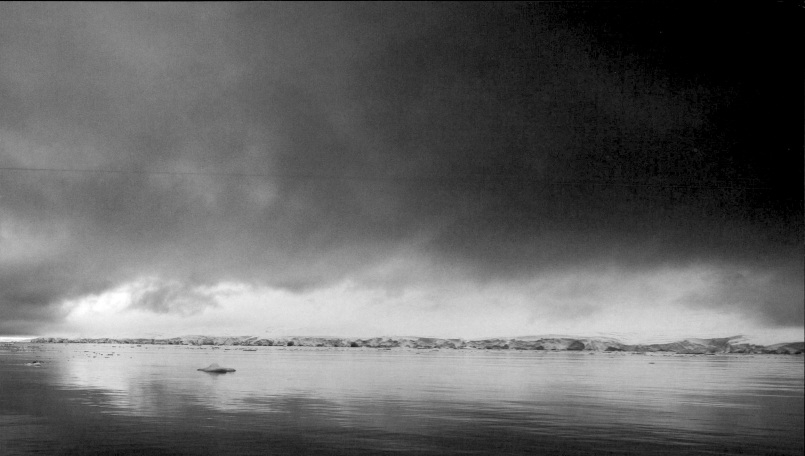

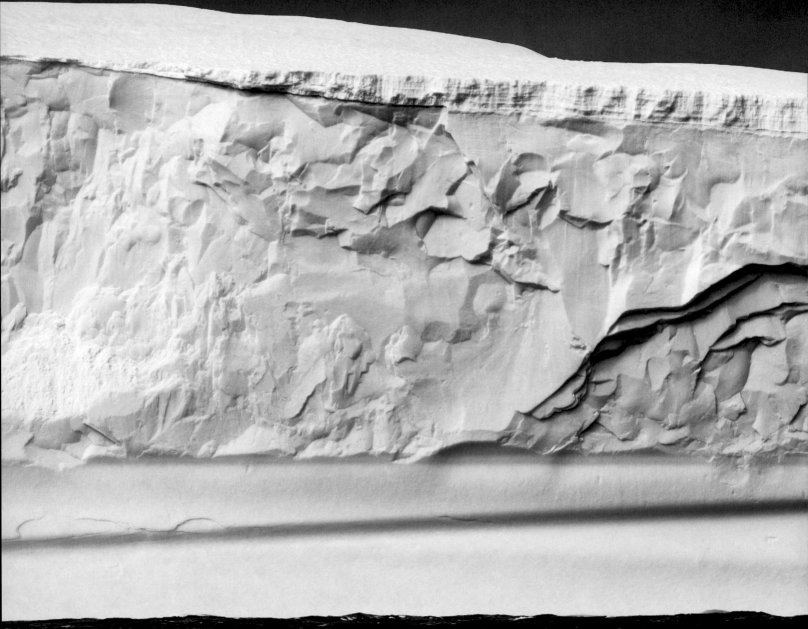

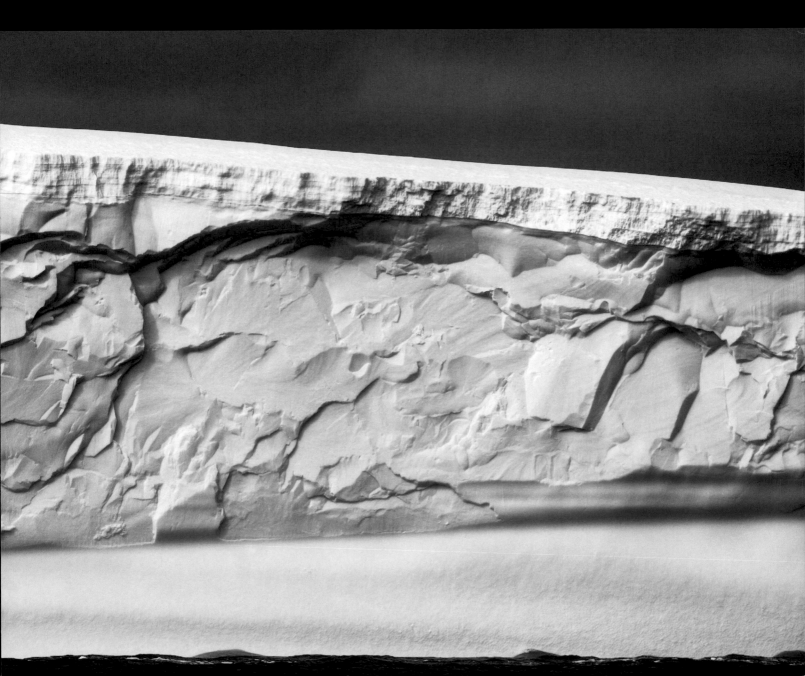

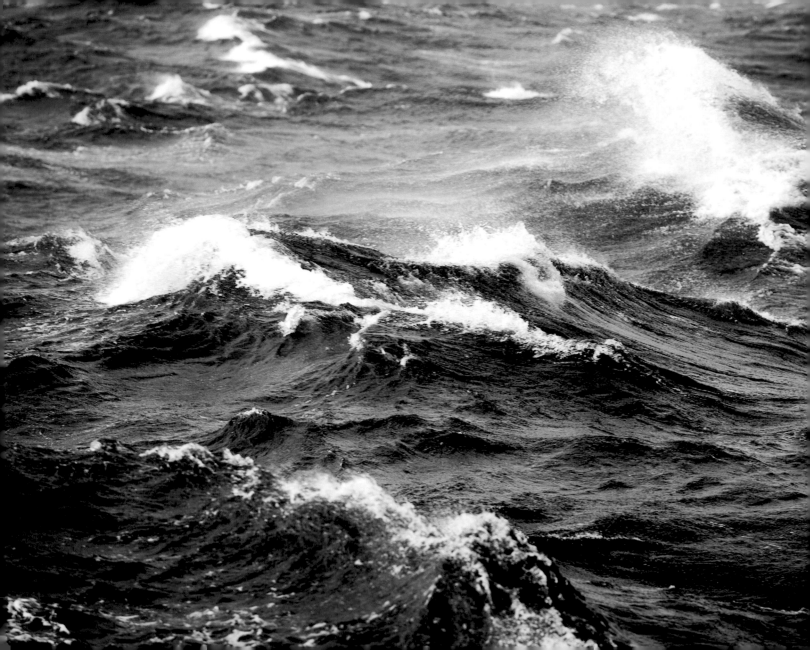

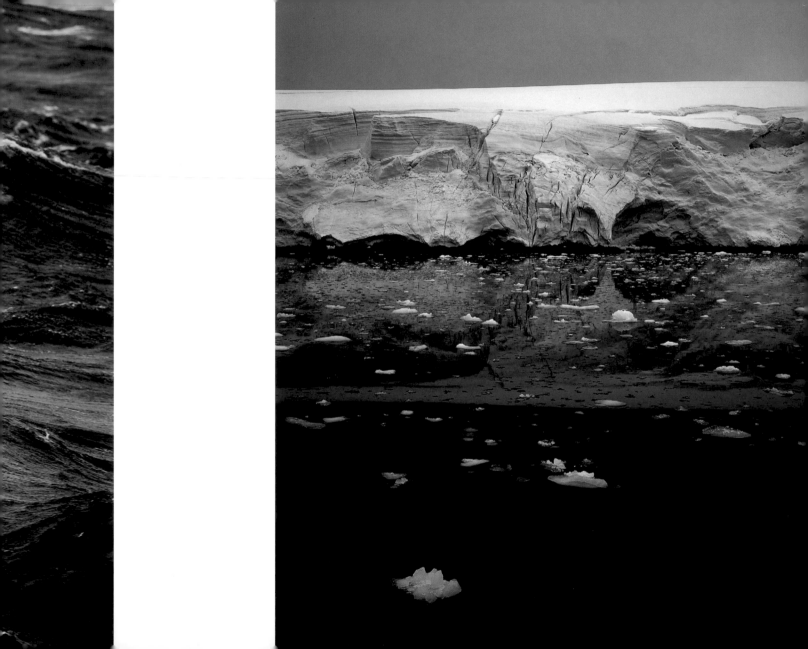

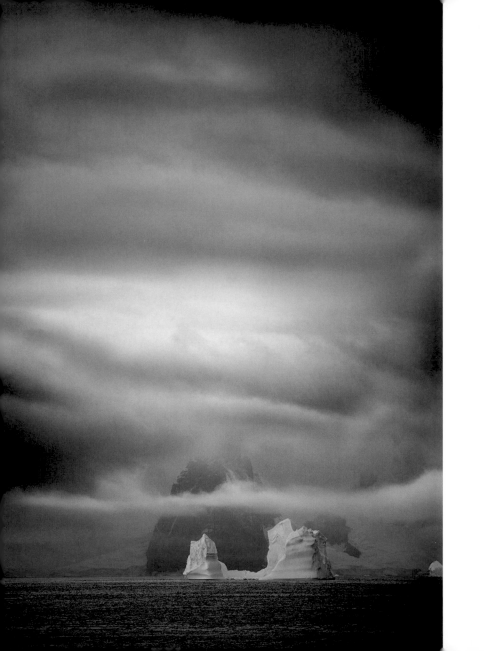

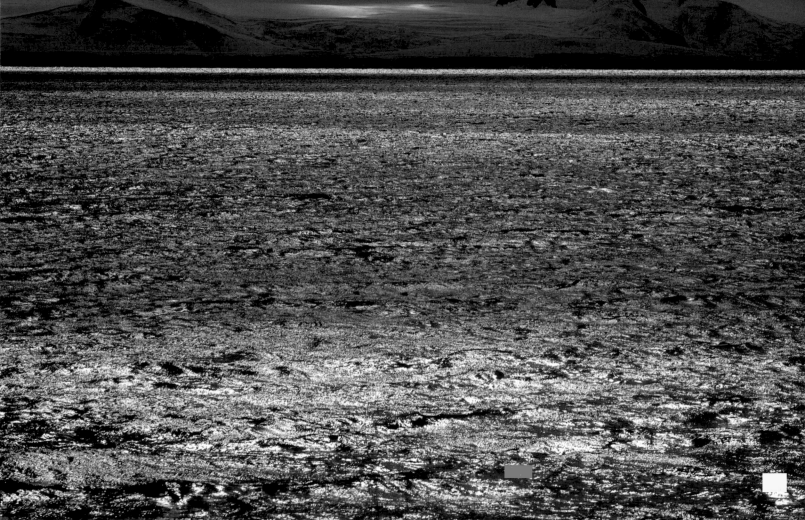

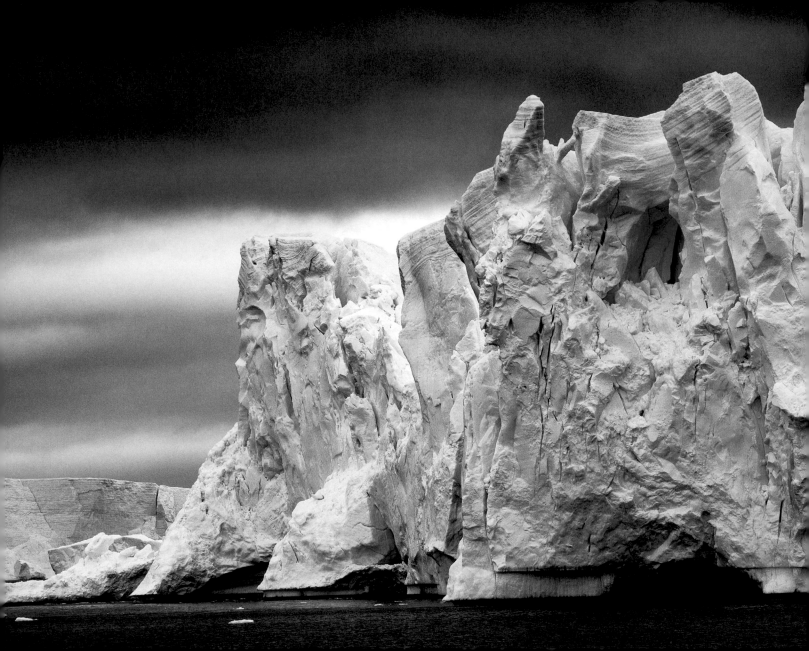

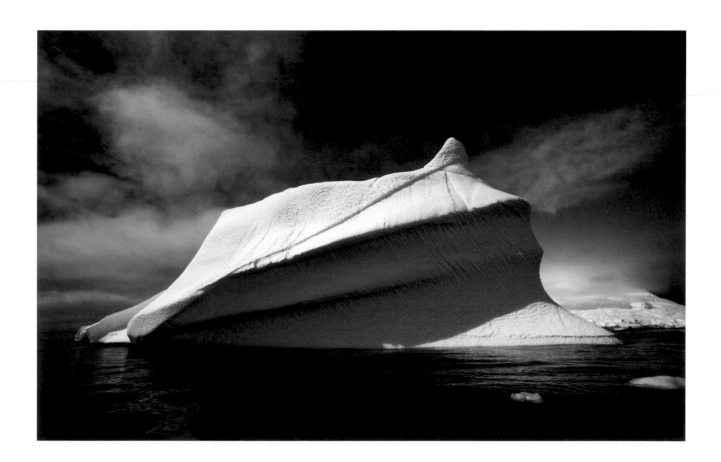

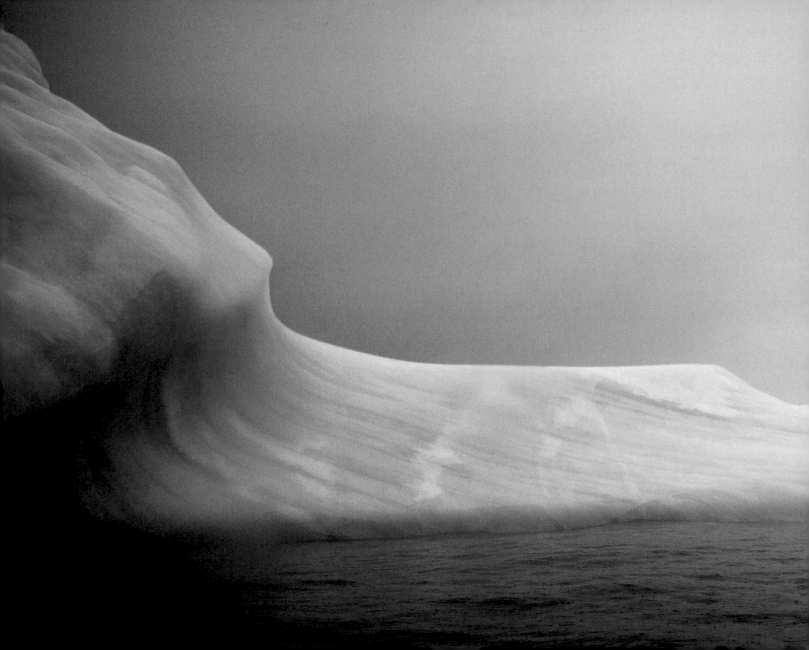

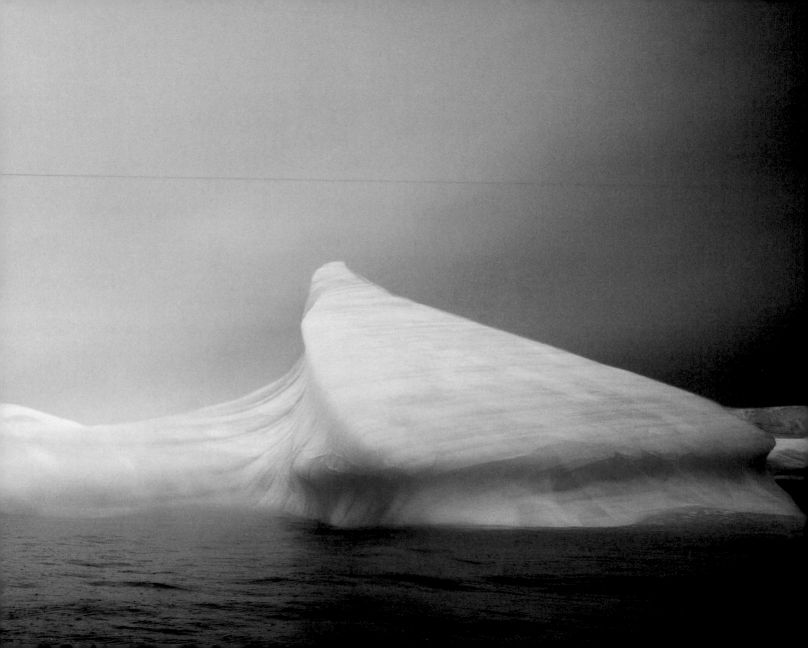

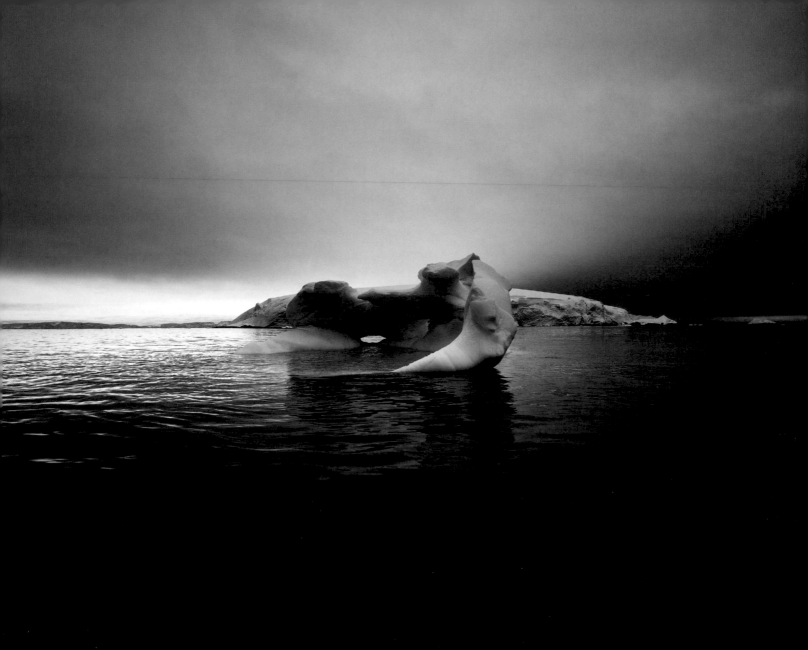

David de Rothschild

The extraordinary experience of spending more than eighty days in Antarctica left me with an insight that will stay with me for the rest of my life. My revelation took root when I stood at the bottom of one of the world's largest glaciers, Axel Heiberg in the Trans-Antarctic Mountains. It grew over the course of the next three months, during which time I felt like nothing more than a speck of dust on the endless horizon of what is arguably Earth's most majestic and environmentally significant continent. It was in Antarctica that I truly began to grasp the scale and complexity of the consequences of climate change. While the planet's fragility was highlighted, the vulnerability of humankind was staring me in the face.

Melting sea ice, lethal storms, floods, disappearing glaciers, forest fires, fatal heat waves—these are the costs of living beyond our ecological limits. Climate records show that the six warmest years in the past century-and-a-half have all occurred since 1998. This warming is destroying our planet's most fragile ecosystems, including the polar regions. If we continue with business as usual, global temperatures could increase by up to 5°C. If that happens, no matter how we slice it, things will become very uncomfortable.

If we look back in history we see that the warning signs have always been there, from Jean-Baptiste Fourier's coining the greenhouse analogy in 1827 to Roger Revelle's prescient statement in the mid-50s that humanity was conducting a "large-scale geophysical experiment," but we didn't look and we didn't listen.

However, whether it was the environmental emergencies unfolding in front of our very eyes, or the increasingly alarming reports from the scientific community, or the unprecedented media attention, 2006 must go down as the year that we began to read the signs, the year that environmentalism became mainstream. As the political writer Thomas Friedman quite aptly phrased it, "Green is the new red, white, and blue."

We are newly greened and newly awakened to the nature of global warming. We know that human activities have caused it and that human activities can begin to reverse it. The problem is clearly defined and within our power to solve.

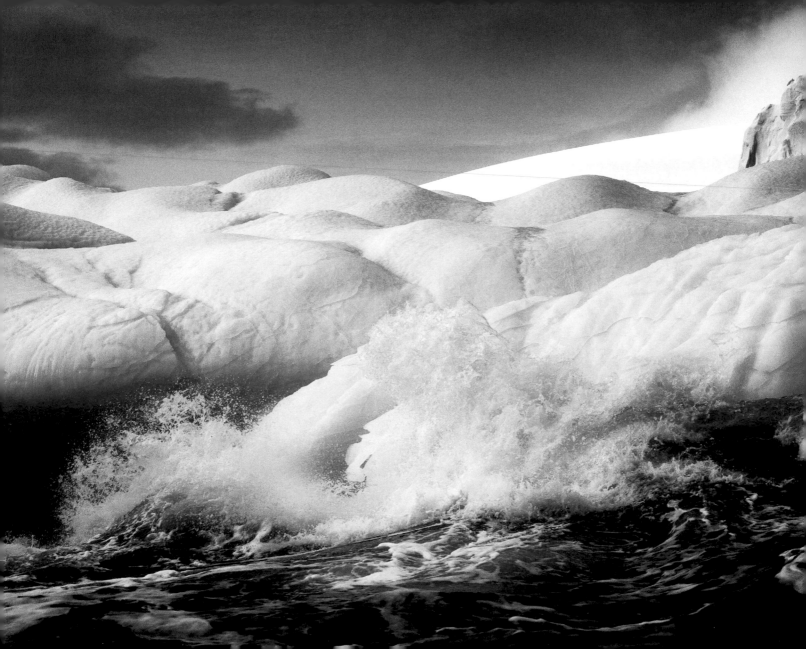

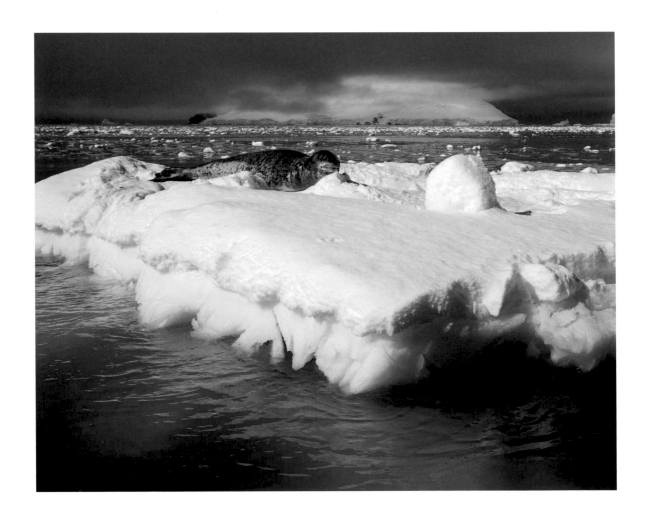

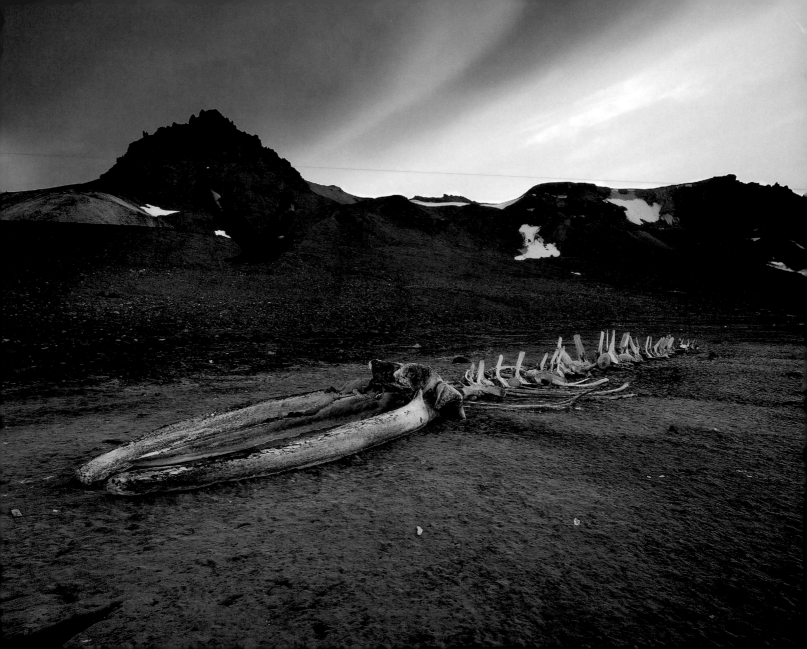

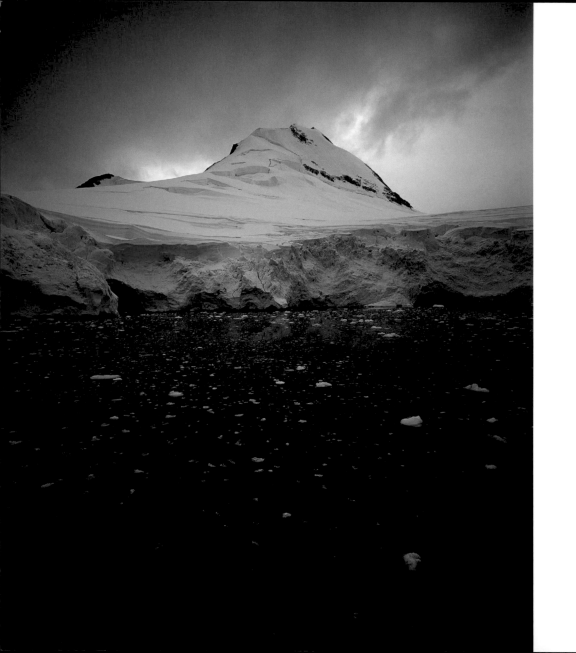

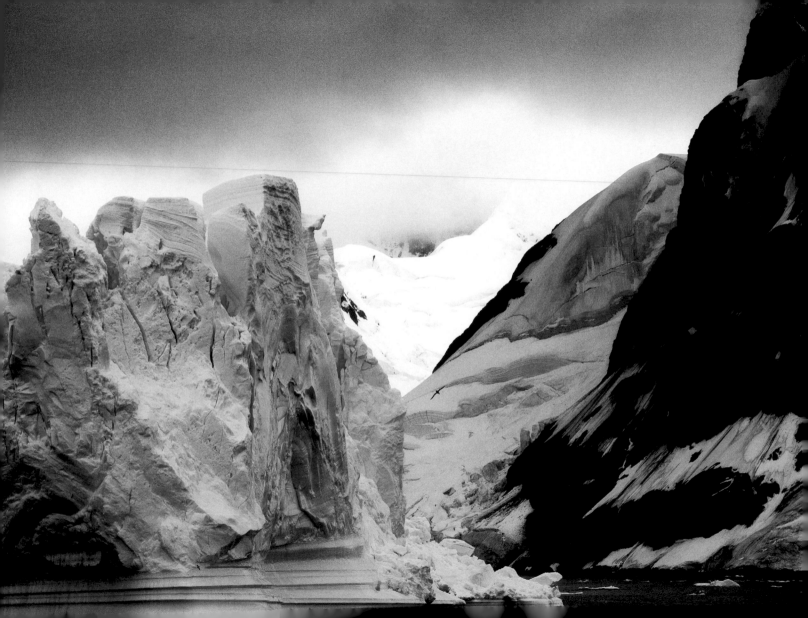

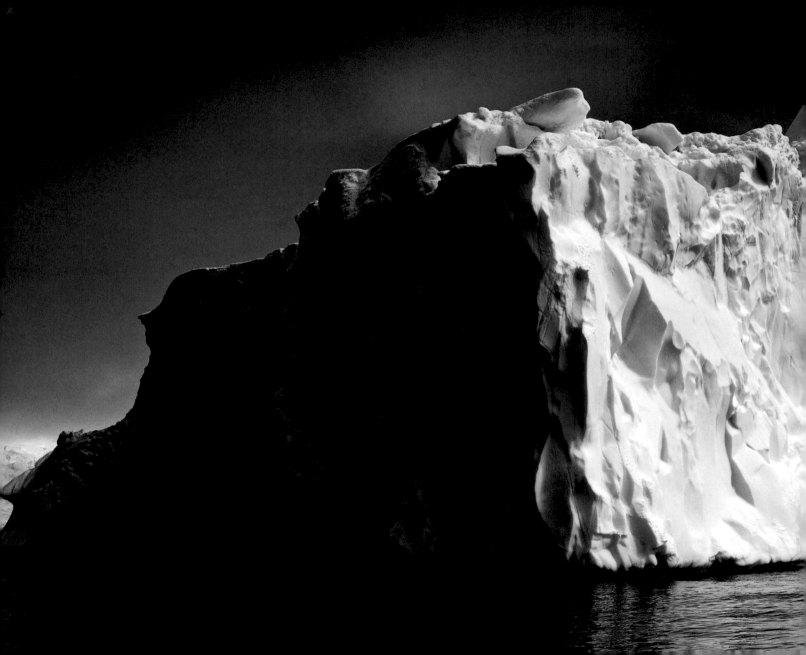

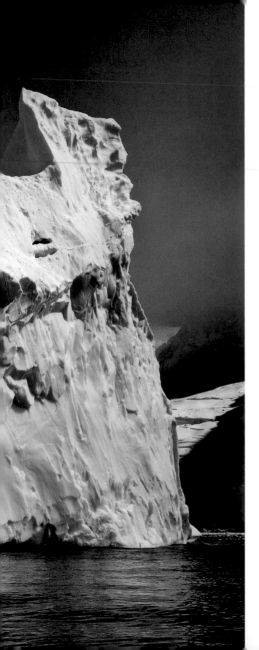

67

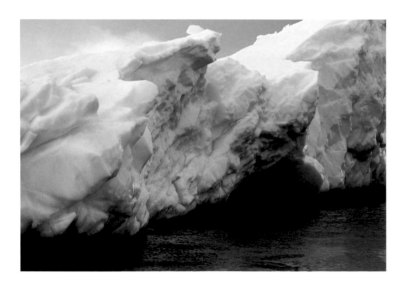

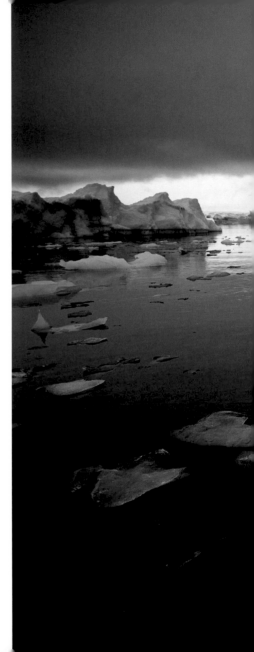

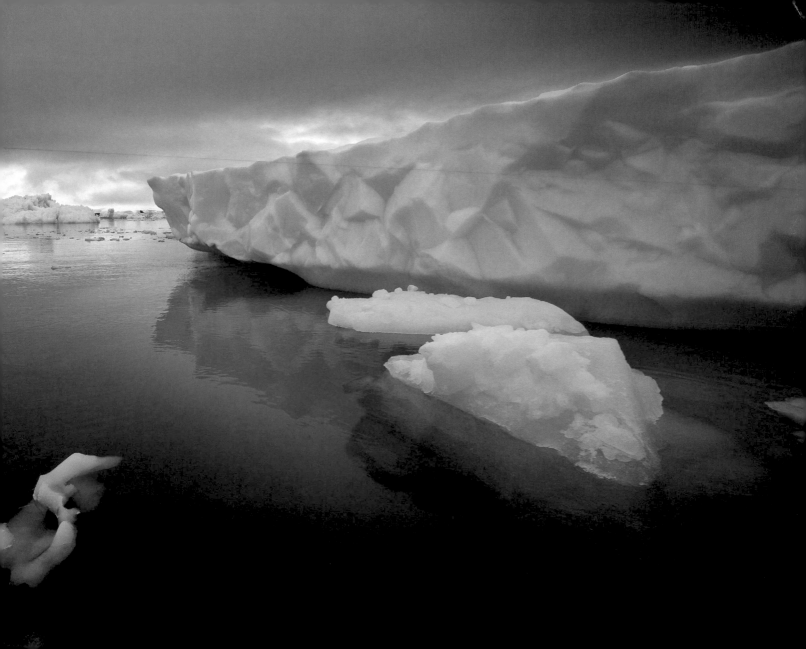

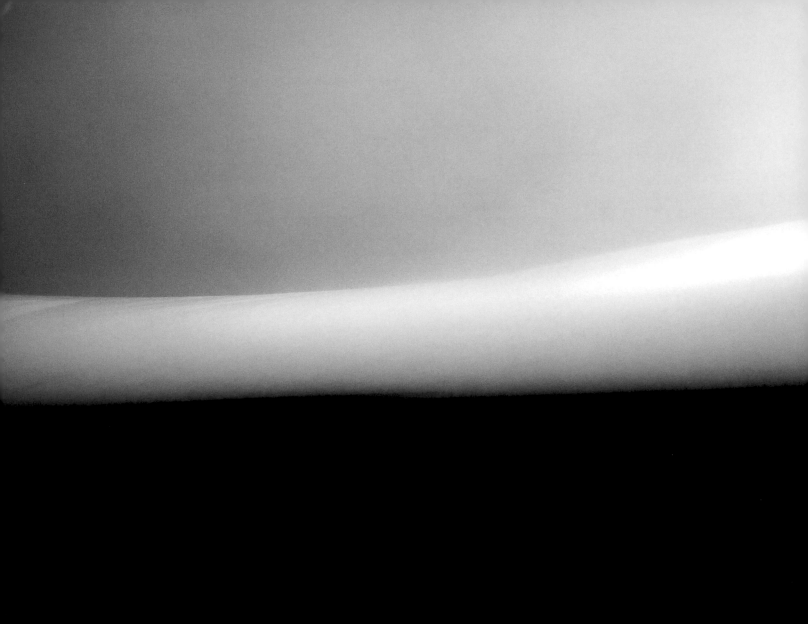

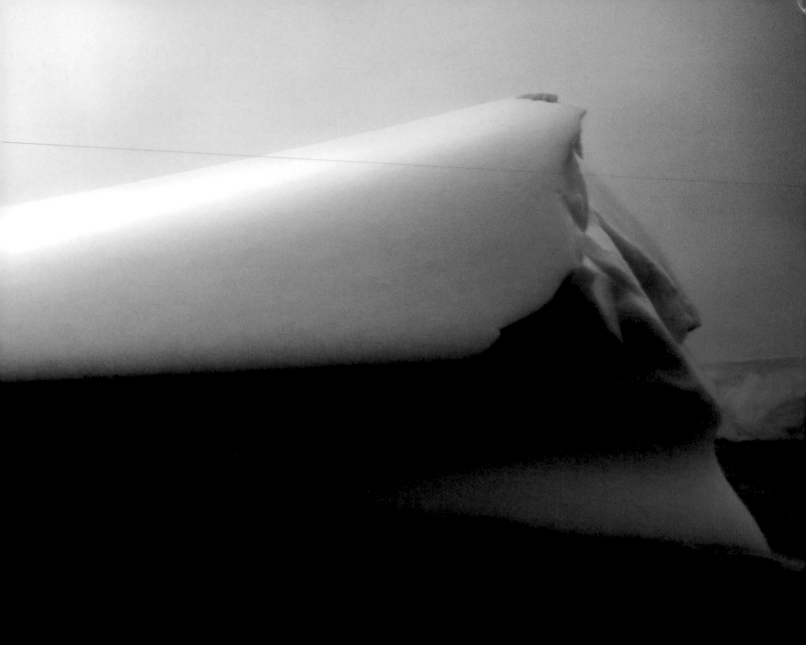

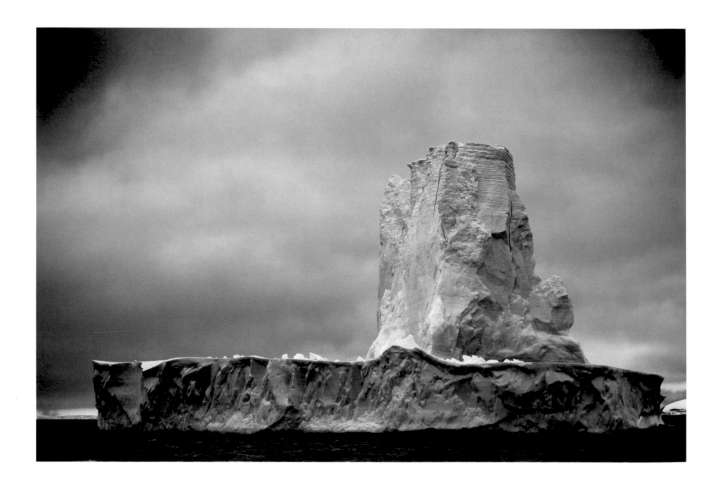

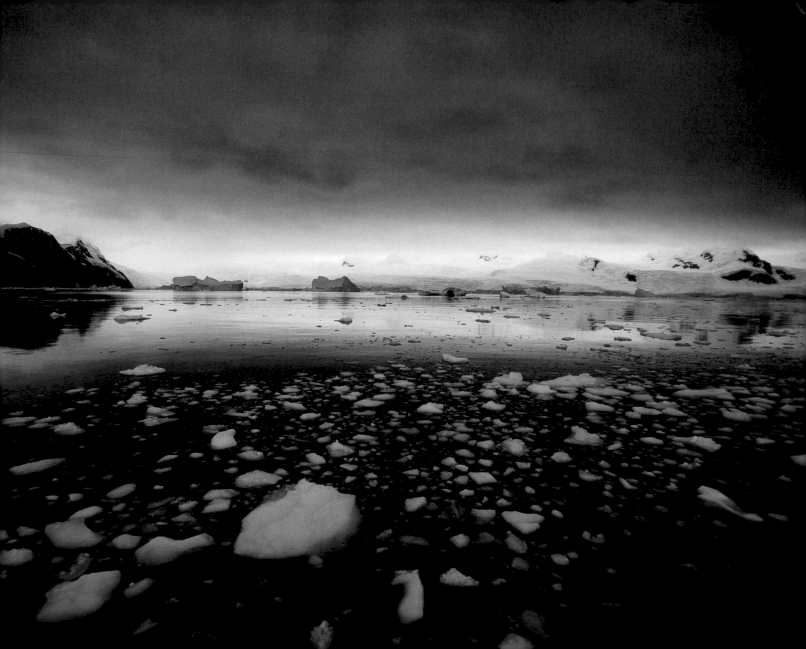

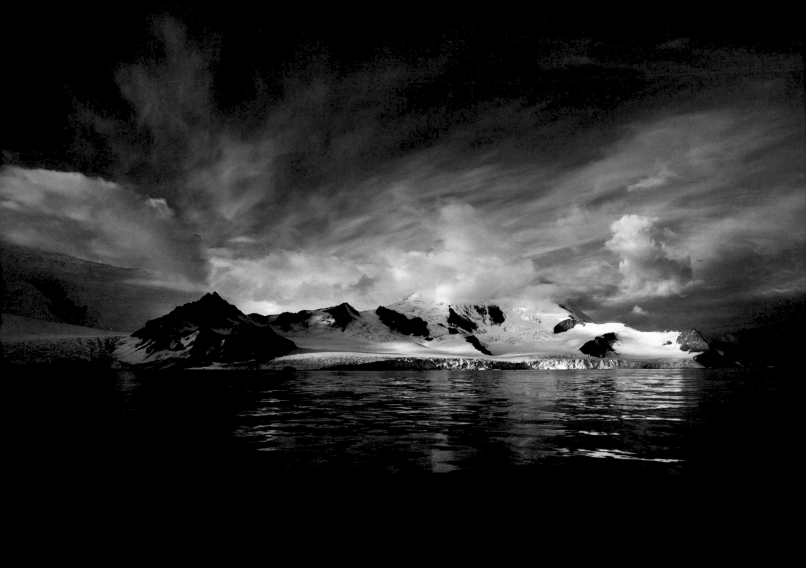

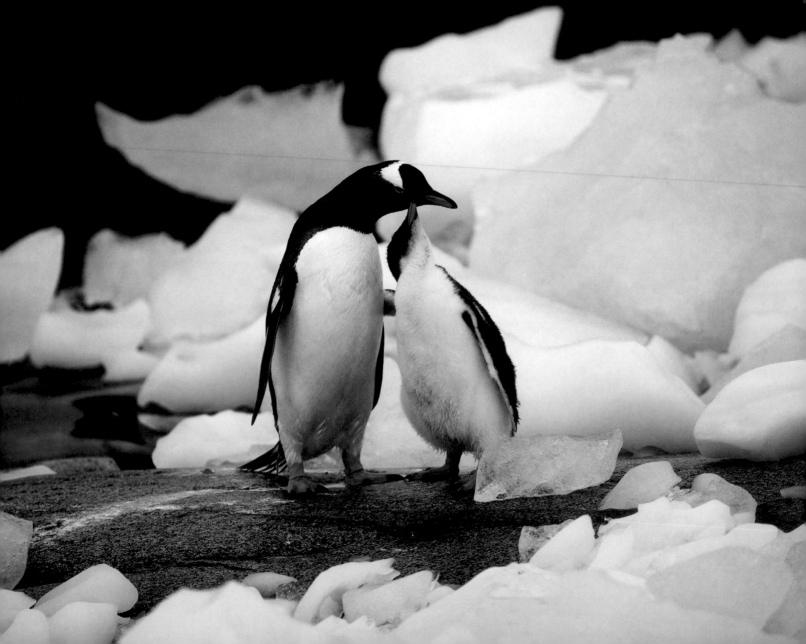

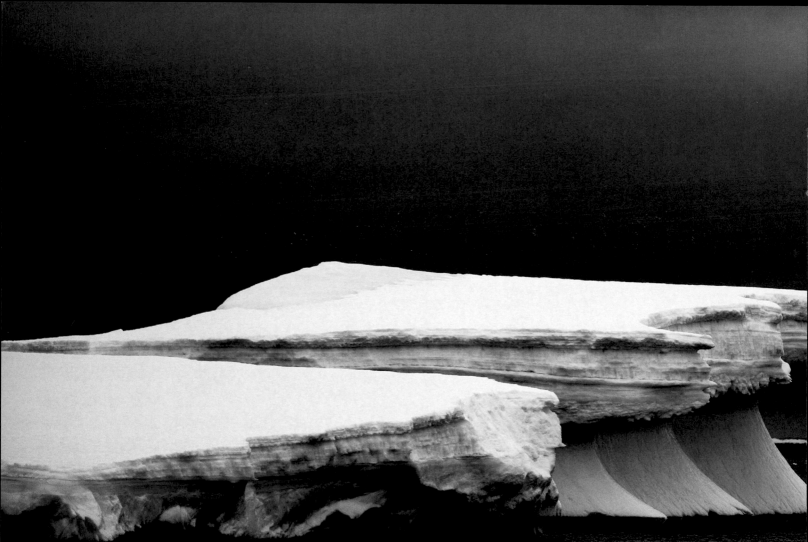

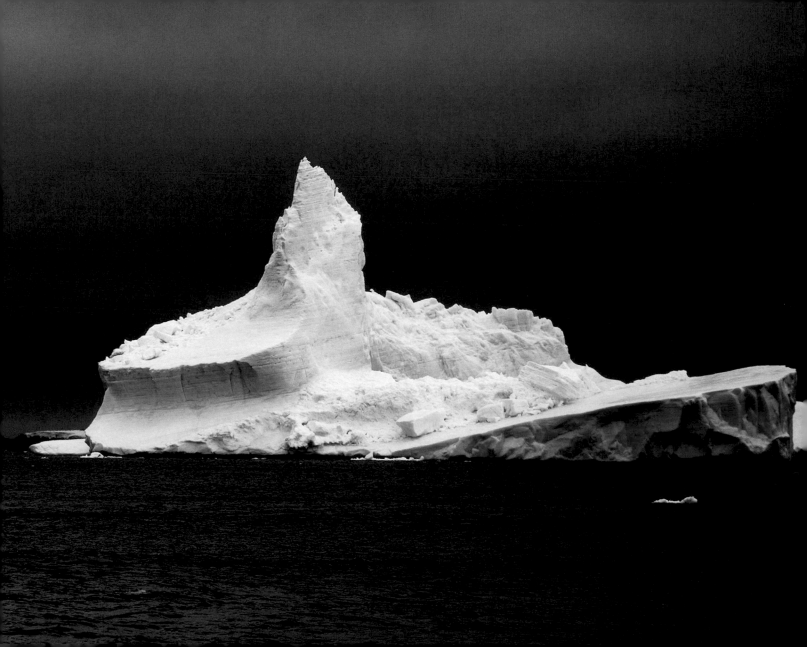

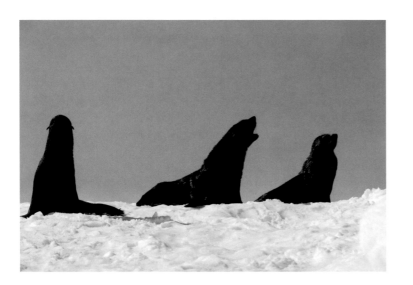

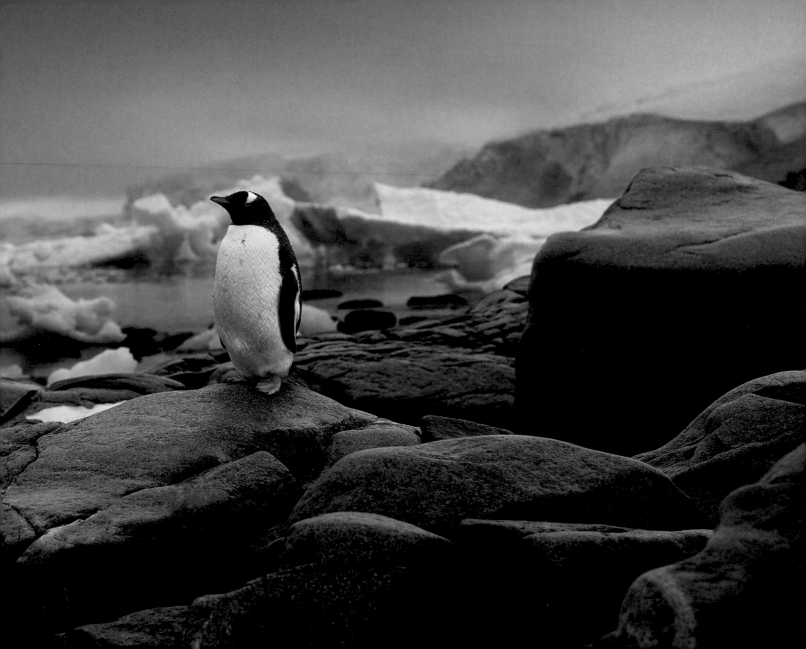

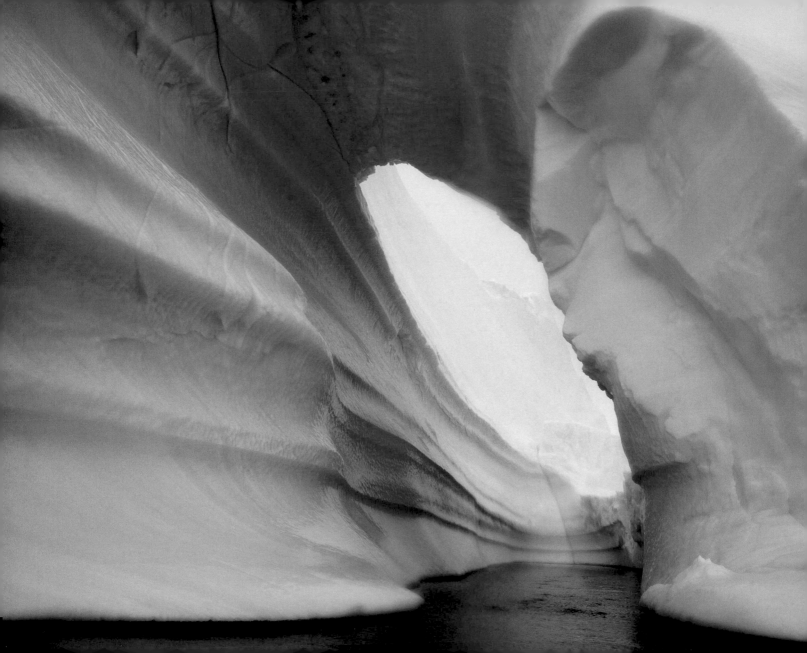

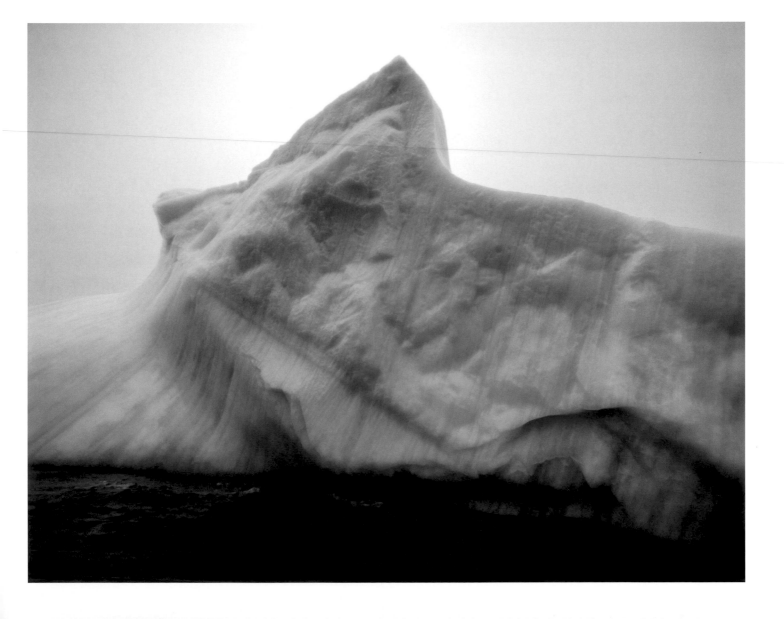

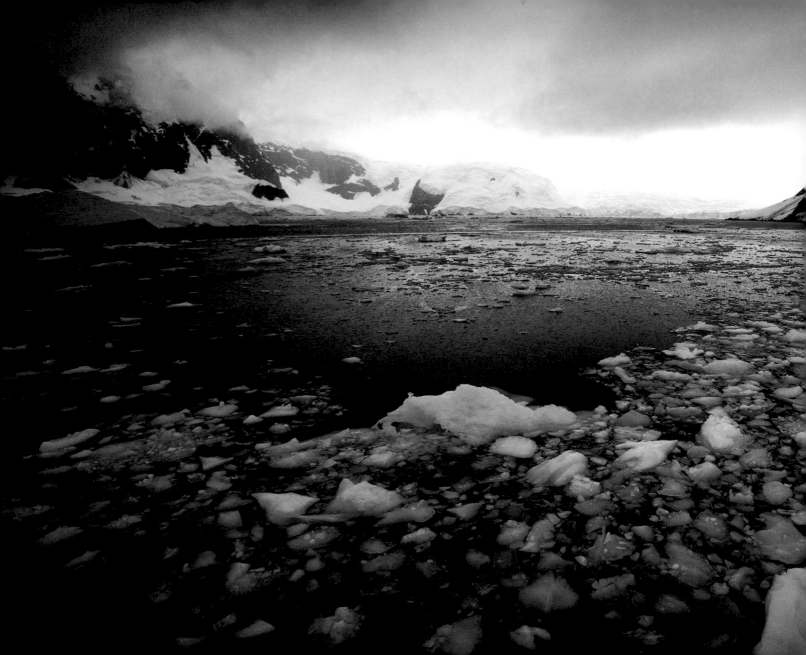

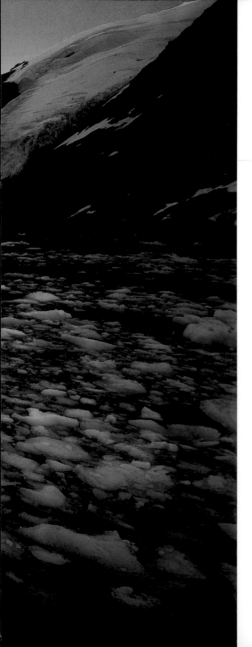

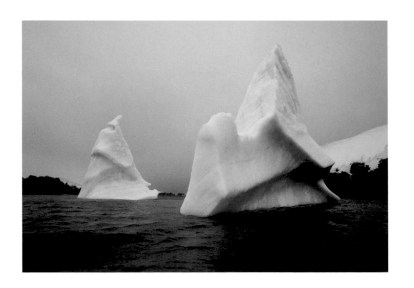

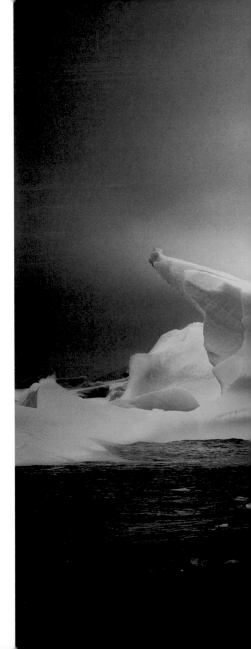

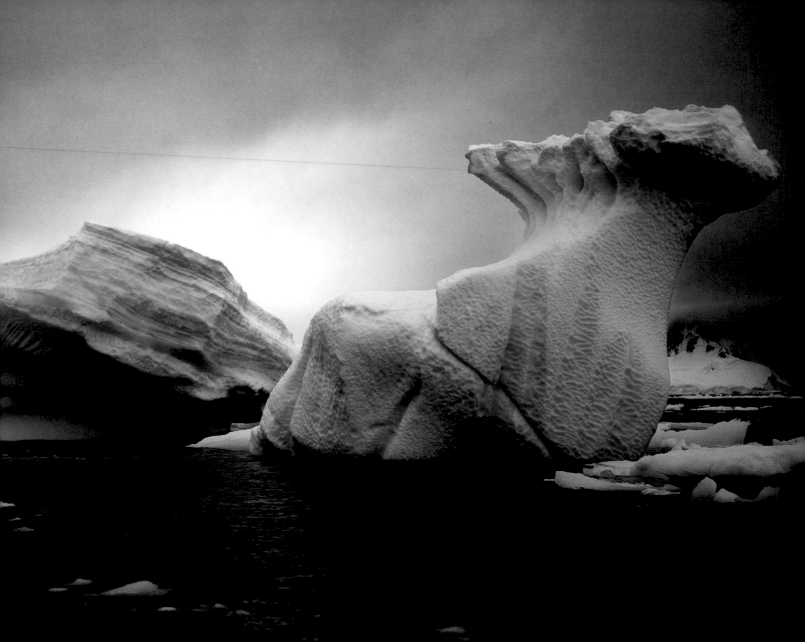

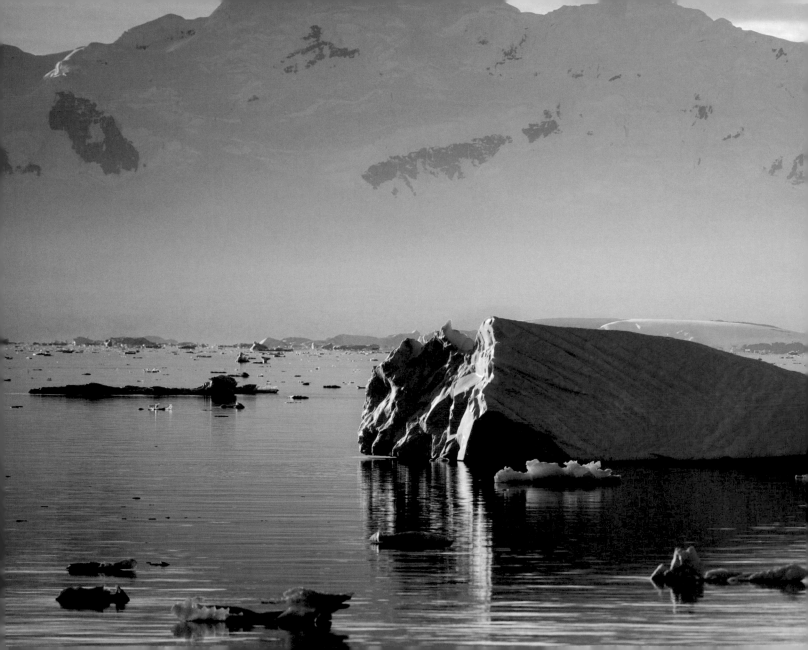

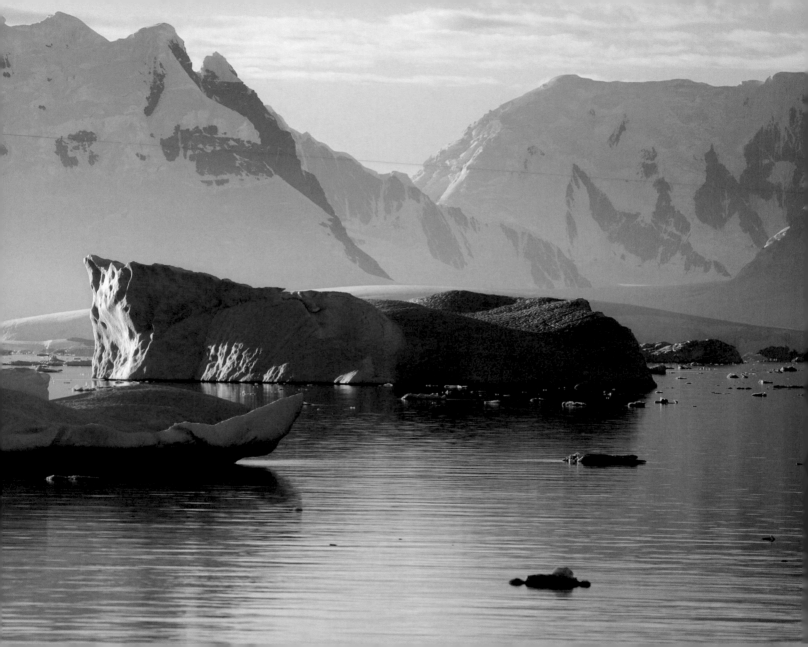

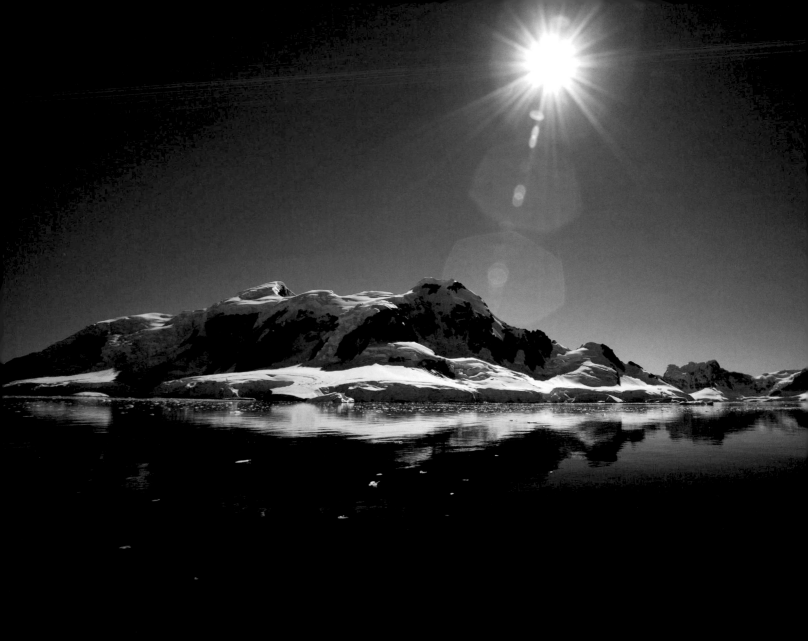

"Be the change you wish to see in the world."—*Mahatma Ghandi*

A CALL TO ACTION

I did not set out to become an environmentalist. Upon traveling the globe, I was shocked by the lack of common sense and shortsightedness that has defined our evolution. Confronted with a persistent self-examination of the nature of my own footprint, I discovered many disturbing facts which have led me to wonder: how did we get here? How did we develop, over the course of our 150,000 year history, from a largely holistic and sustainable culture to one which—in the industrial world at least—produces thirty-six units of waste for each unit of product? How do we now purport to provide for our children while poisoning the air they breathe, the food they eat, and the water they drink?

With only 5 percent of the world's population, the U.S. consumes 30 percent of its resources and produces 30 percent of its waste. There are seventy-two insecticides, pesticides and herbicides sprayed and genetically added to the most common US fruits and vegetables. We inject our animals with steroids, hormones, and antibiotics. And then eat them! 81 percent of the population is overweight, but 850 million people in the world are without sufficient food, while we subsidize our farmers to produce less. The U.S. admits to producing 4 billion pounds of toxic chemicals a year (not counting those produced overseas). There are chemicals, parasites, heavy metals, and bacteria in the water we use to wash and drink. 4 percent of our original forests are left and 40 percent of our rivers produce undrinkable water. And this year California and Oregon placed a moratorium on all commercial and recreational salmon fishing due to an alarming reduction in their reproductive cycles caused by warming trends and pollution.

Wildfires have increased by a factor of four since 1986, closely associated with warmer summer temperatures. Droughts, hurricanes, mudslides, and glacier depletion have seen steady increases globally over the last three decades, as have famine and dysentery. In 2100 we will be 500 percent richer but the earth will be four degrees warmer, threatening our ability to live on the lands we cultivate. The Earth is calling. And what it is saying isn't "Help," but rather, "Beware."

The convenience of technology has blurred our relationship to common sense. If we relied upon candle light alone to illuminate our homes, it is doubtful that people would burn candles all over their property and keep them lit all night. Or all day. Should we, as well, accept that a benchmark of industrial progress is the advent of single use disposable plastic—burying bags or bottles into landfills, or converting them to toxic fumes? The IPCC tells us that we have twenty to thirty years to reverse the adverse effect of our consumption habits—and our relationship to energy—before we cross the tipping point of runaway global warming.

We need to re-think everything! We have proven to be a most resourceful and creative species. And with endless renewable energy at our disposal, the future can be bright. And clean. It is up to us. So here is a starting point: if you can change three habits to reduce your daily footprint, you are bound to do more. You will feel better, become an example to your family, and an advocate to your peers. You will get us one step closer to reaching critical mass. The clock is ticking. You are three steps away from changing the world! Let's get started:

Change How You Live

LIGHT UP: Replace incandescent bulbs with fluorescent bulbs in your home. Energy efficient lighting lasts up to 100 times longer than incandescent bulbs; this reduces energy consumption and lowers utility bills. Remember to turn off the light when leaving a room.

RE-USE, RECYCLE & REDUCE: Recycle aluminum, glass, plastic, and paper. Reuse what you can before recycling it. Set a goal to lower your waste, as well, by composting.

ELIMINATE JUNK MAIL: Reducing annoying junk mail saves trees and energy. Services such as greendimes.org or 41pounds.org will remove you from unwanted junk mail listings.

SHOWER: Taking showers instead of baths and decreasing the length and temperature of your shower reduces the carbon needed to heat the water.

GREEN YOUR BILL: Most energy companies give you the option to use renewable energy on your water and power bill. Make sure to exercise that option.

TURN IT DOWN, TURN IT UP: Minimizing your heater and air conditioner use reduces greenhouse gas emissions and your electricity bill. After the refrigerator, air conditioning is the second biggest consumer of electricity in an average household.

USE EFFICIENT APPLIANCES: Buy Energy Star refrigerators, washing machines and other appliances and save money. Always run full loads of dishes and laundry, and use cold water. On sunny days, hang clothes on a line to dry.

INSTALL EFFICIENT TOILETS: Buy low-flow toilets that can save up to 22,000 gallons of water per year for a family of four. New toilets use 1.6 gallons per flush compared with old toilets that require 5 to 7 gallons per flush. Fix leaky faucets and toilets.

FAN IT: Installing a whole-house or ceiling fan improves interior comfort and reduces electrical bills. Fans can be adjusted to either draw warm air upward during summer months or push it downward during the winter.

INSULATE MORE: Adding insulation to walls, attics and basements decreases heat loss. Double-paned windows save you energy and money.

UNPLUG IT: When not in use, unplug your televisions, cell phones, computers and appliances. Turn off power strips at night, and cut down on your utility bill.

USE CHEMICAL-FREE CLEANERS, PAINT: Toxic chemicals can be found in many household cleaners, releasing toxins in the air and water. Purchase paint that contains little or no volatile organic compounds. Never pour toxic chemicals down the sink.

USE SOLAR POWER: Install solar panels to reduce CO_2 and electric bills. The sun can heat your water, too, reducing expenses and cutting carbon emissions. Let the sun warm your home naturally. Shading south-facing windows with deciduous trees, for example, reduces heat gain from the summer sun but allows winter sunlight in to warm your home during colder months.

PLANT LOW-WATER LANDSCAPES: Replace your lawn with native wildflowers, shrubs, grasses and groundcover. Native plants are less water intensive, especially in arid climates.

ELIMINATE USE OF FERTILIZERS AND PESTICIDES: Residential use of pesticides accounts for about 8 percent of all pesticide applications. Urban runoff accounts for about 14 percent of common water pollution and just over half of that is due to residential use of fertilizers.

NEWS ONLINE: Reduce energy, wasted paper and toxic ink by reading your news online. On average, less than 5 percent of newspapers are actually read; even less with the Sunday edition.

BE CURIOUS: Use the best resource available – your head! Be inquisitive and use common sense. Educate yourself and engage your children. Purchase *The Green Book* and discover even more simple, everyday steps that we can all take to reduce our footprint. Start a neighborhood group and learn more about how to green your town and get involved by visiting www.globalgreen.org/greentowns!

Change How You Travel

DRIVE LESS: By choosing to bike, carpool, walk, and taking public transportation, you will help reduce the leading cause of greenhouse gas emissions. Saving money and getting in shape are bonuses!

DRIVE SMART: If you must use a car, drive a hybrid, biodiesel or electric vehicle. By purchasing alternative fuel vehicles, you urge automakers to address green house gas emissions by producing smaller cars that get more than thirty-five miles per gallon and run on alternative fuel. Whatever car you drive, inflate the tires to improve fuel economy.

LIGHTEN UP: Don't drive around unnecessary cargo. Every 100 pounds eats up an extra mile/gallon. Roof racks also increase wind resistance, lessening fuel efficiency.

SLOW DOWN: Observe speed limits; it's safer and saves gas. Gas mileage declines rapidly above 60 mph. Accelerate smoothly and brake gradually. Aggressive driving can lower your gas mileage by thirty-three percent at highway speeds.

SHARE CARS: Instead of keeping and maintaining a second vehicle for occasional use, rent one when needed. For commuting, enroll in a car-sharing program such as Flexcar or Zipcar and give yourself the flexibility of access to a car when you need it and the freedom from it when you don't.

TREAD LIGHTLY: Invest in a Terra Pass or green tag to offset the CO^2 impact of your driving or flying. Green tags fund clean energy projects including wind farms, methane capture, and more.

Change How You Shop

TOTE IT: Carry a canvas bag in your car and refuse to use disposable paper or plastic at the grocery store. Bring your own canvas bags and reuse them week after week. The US alone discards 100 billion plastic bags each year—the equivalent of 12 million barrels of oil. That is an area the size of Texas, of which only 2 percent of those get recycled. These bags alone clog up the recycling plants with their sheer volume.

AVOID PLASTIC, PACKAGING: Shop for food with limited packaging, and don't buy plastic bottled water. The US uses two million plastic beverage bottles every five minutes. Each year, Americans throw away 22 billion plastic bottles, 90 percent of which end up in landfills. Plastic bottles create toxic air pollution as they are incinerated with regular trash. If you must, refill plastic bottles with water filtration tap devices. Many "mineral" water companies use un-filtered tap water to fill their bottles!

BUY SECONDHAND: Not everything needs to be new. Purchasing "gently used" clothing, furniture, and goods is lighter on the wallet and the planet. Consuming less means less carbon-emitting production. Many communities share tools so that not everyone needs to own their own.

SUPPORT FARMERS MARKETS: They reduce the amount of pesticides and fungicides used on foods that wind up in our water supplies. Of the twenty-eight most commonly used pesticides, at least twenty-three are known carcinogens.

EAT ORGANIC & LOCAL: When you buy produce grown regionally, it hasn't been trucked, refrigerated or flown in from miles away. Eating local food once a week saves 5,000 pounds of CO_2 from entering the atmosphere.

CHOOSE WATER-WISE FARMERS: Worldwide, agriculture accounts for more than 70 percent of freshwater consumption, mainly for irrigation of agricultural crops. Support farmers who have switched to drip irrigation.

EAT LESS MEAT: It takes 15,000 tons of water to produce a ton of beef, while a ton of grain only requires 1,000 tons. Meat production also accounts for 18 percent of greenhouse gases.

Change Our Leaders

JOIN THE CLIMATE PROTECTION AGREEMENT: So far, more than 500 mayors have signed the US Mayors Climate Protection Agreement. Tell your mayor to agree to meet or beat the Kyoto Protocol targets for greenhouse gas reductions.

CHANGE ZONING RULES: Urge your planners to develop homes for diverse people near public transit services, shops and jobs. By creating cities and towns with vibrant neighborhoods, more people can choose to leave their cars at home. And building on land in town preserves more of our natural areas with trees and wetlands that absorb greenhouse gases.

PROMOTE GREEN BUILDING: Local governments can mandate green building practices for residences, schools, and businesses. A green building ordinance promotes a whole-building approach by regulating sustainable site development, water savings, energy efficiency, materials selection, and indoor air quality.

SUPPORT SMART WATER POLICIES: Invest in smart water infrastructure and technologies. Tell government leaders to fulfill financial pledges for clean water, and to upgrade and repair infrastructure to reduce the amount of water wasted in urban areas.

SUPPORT SOLAR AND WIND ENERGY: Ask your utility company to give customers a way to buy electricity from renewable energy sources. If it already does, change your plan so that 100% of your energy is green power.

SUPPORT PEACE: Write US and foreign policymakers on the importance of supporting nonproliferation, arms control, and demilitarization worldwide. Cooperation is the only way to sustain life on this planet.

To join this **Call to Action**, visit: www.globalgreen.org/meltingpoles

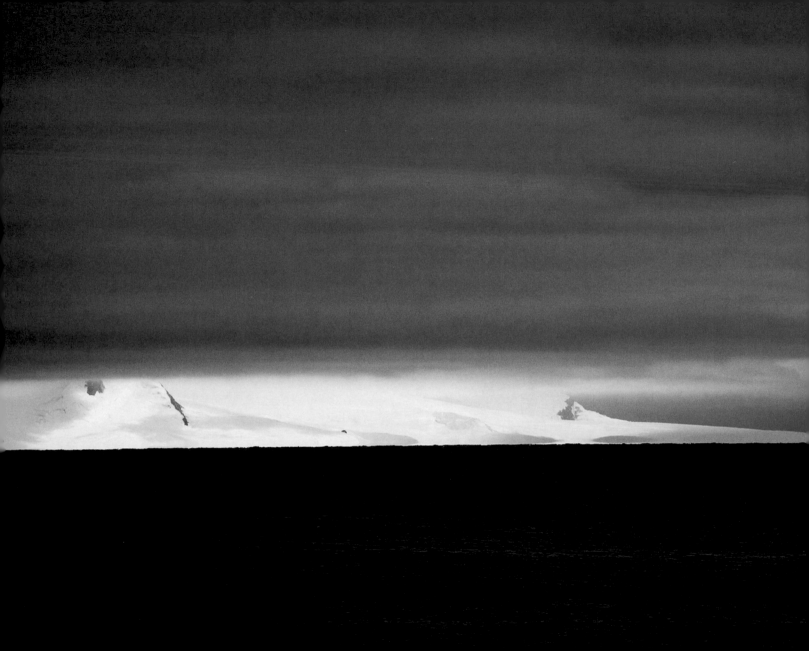

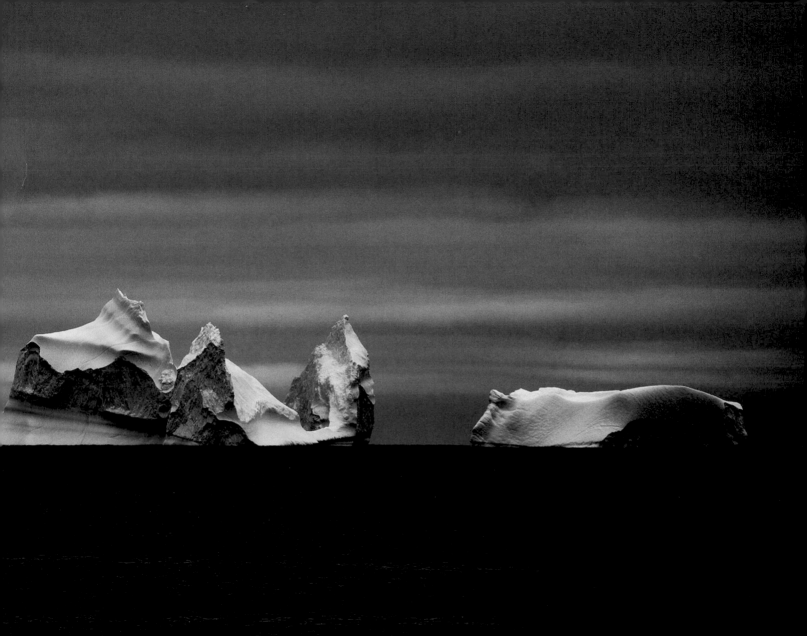

Publisher & Creative Director: Raoul Goff
Executive Director: Peter Beren
Acquiring Editor: Lisa Fitzpatrick
Art Director: Iain R. Morris
Designers: Jennifer Durrant, Barbara Genetin, Mary Teruel
Production: Donna Lee

Earth Aware Editions
17 Paul Drive
San Rafael, CA 94903
www.earthawareeditions.com
415.526.1370

Foreword © 2008 Orlando Bloom

www.antarcticabook.com

ROOTS of PEACE REPLANTED PAPER

Palace Press International, in association with Roots of Peace, will plant
two trees for each tree used in the manufacturing of this book. Roots of
Peace is an internationally renowned humanitarian organization dedicated
to eradicating landmines worldwide and converting war-torn lands into
productive farms and wildlife habitats. Together, we will plant 2 million fruit
and nut trees in Afghanistan and provide farmers there with the skills and
support necessary for sustainable land use.

Library of Congress Cataloging-in-Publication Data available.

ISBN-13: 978-1-60109-027-0

10 9 8 7 6 5 4 3 2 1

Printed in China by Palace Press International